SPIRIT OF 76
LONDON PUNK EYEWITNESS

First Published in the United States of America in 2017 by Anthology Editions, LLC

87 Guernsey Street
Brooklyn, NY 11222

anthologyeditions.com

Creative Director: Johan Kugelberg

Art Director: Bryan Cipolla

Design: Lin Culbertson & Leigh Graniello

Type Design: Kate Bell

Assistant Editor: Alexandra Wagner

First Edition

ARC 047

Printed in China

ISBN: 978-1-944860-05-9
ISBN: 978-1-944860-06-6 (deluxe)
Library of Congress Control Number: 2016959116

SPIRIT OF 76
LONDON PUNK EYEWITNESS

By JOHN INGHAM

EDITED by JOHAN KUGELBERG
FOREWORD by JON SAVAGE

EDITIONS

ACKNOWLEDGEMENTS

In 1976 my *Sounds* editor Alan Lewis knew better than me to follow my instincts. He encouraged me to interview the Sex Pistols immediately after my first experience of them and to follow the movement as it grew. As the year accelerated and new bands appeared I saw almost no one was documenting them on film, so I picked up a camera. Not planning to get my work published, I shot with color film; at the time all the professional outlets used black and white, so accidentally I created one of the few records of how vibrant the first year of Punk looked. Seen only by a few friends, the images were packed away as I turned in other directions.

Two years ago Johan Kugelberg saw them and encouraged me to bring them to a wider audience. When I was starting to write this book, Jon Savage made sure my sights were set correctly. Cindy Stern showed me how it felt to be one of the first Sex Pistols fans. Mark Selby, Paul Wexler and Stewart Joseph gave invaluable feedback during early drafts; their thoughtful comments contributed greatly to the finished work.

1976 was a very memorable year. In documenting it, fellow writer Caroline Coon gave support, insight and thinking as the months progressed. Most important were the first fifty fans. Without them none of this would have happened.

NB: I wrote under the *nom-de-typewriter* "Jonh Ingham." In the ways of the digital world my teenage trick to get noticed can't be accommodated on the cover of this book. But if you want to read the original pieces from 1976, google under "Jonh."

Foreword

Jon Savage

We're talking ten days. The bulk of these photos were taken at three crucial November 1976 shows: on the 5th, the Clash and the Subway Sect at the Royal College of Art — billed as "A Night of Treason," so apt for that venue situated hard by those establishment monoliths the Albert Hall and the Albert Memorial; on the 11th, the Clash and the Subway Sect at the Lacey Lady, a predominantly soul boy club in Ilford; and, on the 15th, the Sex Pistols at the Notre Dame Hall, just off Leicester Square.

The first was a show played to dozens of people; the second, to a dozen; the third — thanks to LWT television, who were filming the event — to a potential London audience of millions when it was transmitted a couple of weeks later, on the 28th of November. Taken as pure reportage, Ingham's photos capture UK punk rock — or new wave, or ? rock — the naming, like the clothes and music, was not yet completely solidified — just before it hit the mass media.

"My week beats your year," Lou Reed had written on the sleeve of *Metal Machine Music*. That was the credo of British punk as it accelerated during the late autumn of 1976. It had been growing since the spring, but in October and November it hit warp speed. As Ingham notes, the original 50 to 100 outcasts and weirdos were being supplanted by a fresh wave of outcasts and weirdos; you can see the energy in these photos as more young people arrive, their lives changed.

It's all still homemade and fresh-faced: hard drugs haven't yet wreaked their havoc, while the clothes are a delightful mixture of original fashions purchased mostly from SEX and creatively detourned second hand clothes: PVC, school ties, straight-leg trousers. Johnny Rotten had customized his white shirt with stickers from *The Texas Chainsaw Massacre*, then playing in the UK with a limited London release — and some of that film's terror leaked into his performance.

At the Lacey Lady, the Subway Sect are styling their Eastern European austerity look, with guitarist Rob Symmons flying the flag for Mod with his striped shirt and two tone trousers. The Clash are a mixture of Mod — tight skinny trousers, slim ties — and Jackson Pollock: their extremely bright and eye-catching clothes — the colour photos are a real revelation — are emblazoned with Lettrist style slogans, photographs in plastic covers, armbands that read "Red Guard."

The Lacey Lady gig was peaceful, but the others were not. At the Royal College of Art, some long-haired students began pelting the Clash with beer mugs. The group took exception, as did Sid Vicious, who got up on stage looking for a fight. The show ended when Joe Strummer dropped his guitar, leapt off the stage and attacked the offenders. They were rolling around on the beer-sodden floor while the Stooges' "I Wanna Be Your Dog" sucked in all the air — a synesthesia of violent confrontation.

At the Notre Dame, there was a bit of tension — as Ingham notes — between originals and newcomers. Some of the audience resented the presence of the camera crew, whom they proceeded to douse with spit. Vivienne Westwood poured beer over the audience, while Glen Matlock trashed his rig. A mosh pit emerged at the front: it looks tame in the pictures, but it wasn't then. Lydon's performance was particularly ferocious — just watch "No Fun" on YouTube for the full, confrontational, bug-eyed effect.

Days after this performance was transmitted, Punk became a national scandal. After the Bill Grundy incident, it wasn't about music anymore but the mass media. Ingham's photos capture this last phase of innocence, of quickening energy and possibility, of a still-lively humour. Punk was exploding. The groups were getting faster and harder, more confident. It was all hurtling towards something, everyone could feel it. What that something turned out to be is now known, but it wasn't then.

These photos should be read in conjunction with Jonh Ingham's wonderful 1976 articles, which you can find on the web and in Rock's Backpages. You can tell what a fine writer he is by his introduction here. Along with Caroline Coon, Ingham was the first to document British punk in the weekly magazine *Sounds*. His allusive, scientifically precise prose helped to shape the movement as it developed during spring, summer and autumn 1976. He was there, at every major event.

He regarded his role as that of a catalyst: "There is no point in writing about this analytically. The point is to encourage this, because we need it. We're going to appeal to some kid about nineteen, reading *Sounds* in the suburbs who is as bored with the fucking situation as I am. And is looking to get excited. Telling him about three chords in the key of E, all that shit, is not going to get him excited. Telling him about this madman who's going to leap off stage and punch people… that's interesting."

"The thing that impressed me through that first nine months was how intelligent the whole thing was. I remember that disco out in East London where the Clash played, and bin-liners had just showed up for the first time, a couple of weeks earlier. Mick Jones and I were just falling about, talking about how it was so fucking stupid, but what a great idea, you know. At that point it was just another alternative, it wasn't the uniform or anything."

"Mick was saying how intelligent the whole movement was, but at the same time there was this real undertone of stupidity. That was part of what was so appealing. He said, 'When it gets popular, it's going to get really stupid.' There's prophetic words. I never really thought about the effect that people were getting from the writing I was doing. But it was

the only place that it was being treated positively. The fact that it was being done in an intelligent way meant that it was appealing to intelligent people."

Ingham quit *Sounds* in late 1976 to become co-manager of the hot new group Generation X. Their pictures are in the later half of the book — including a wonderful, hitherto unseen shoot under the Westway / Shepherd's Bush spur roundabout — as well as photos from the New Year's Day 1977 Clash gig at the Roxy and the Damned at the Hope and Anchor in early 1977. But by then he had ceased to be a documenter and become more a participant: a path that would soon take him to Los Angeles and the madness there.

I must declare a personal interest. I attended two of the three 1976 shows that Ingham photographed, and they changed my life. I met Jonh at the RCA and he was immensely kind and patient with my manic burbling. "You were SO certain about everything," he told me years later. That was the beginning of a friendship that has lasted for forty years, across the Atlantic and back again. I've always loved his photographs and am really pleased that now the world will see how good they are.

Introduction

Jonh Ingham

ONE

The fourth of the fourth, 1976. Sunday night. From the street the El Paradise strip club is all warmth and invitation. "This is the Naughtiest Show in Soho," they promise. Step through and behind the neon and gold flocked wallpaper is a nearly-lit room with peeling black walls and a sticky concrete floor, empty except for three and a half rows of broken down cinema seats almost facing a tiny mirror-backed stage. After 30 minutes I can still smell the slight, sticky scent of semen and bleach.

Filling the stage is a band that sounds and looks like nothing else in music. The songs are short. They are fast. They all sound nearly the same, but not quite. The band all have short hair. The drummer wears a Pink Floyd t-shirt and above the name he's carved in thick bold pen: I HATE. The vocalist — he's too primitive to call him a singer — is squirming around in Ben Franklin sunglasses and a too-small red sweater ripped up the side and held in places with safety pins. His hair looks like he cut it himself with his eyes closed. His name is Johnny Rotten and he doesn't like you.

About 20 people are watching, a mix of art school creatures, chopped and channeled teenagers, and the staff of SEX, the King's Road avant-fashion and rubber-wear shop run by Vivienne Westwood and Malcolm McLaren, the band's manager. Leaning against the wall in a perfect metaphor of worlds colliding is ersatz rock group Arrows, a made-for-TV trio wearing faded jeans and sneakers, black leather motorcycle jackets and perfectly coiffed rock-and-roll hair. They're probably nice guys with dreams of stardom but they are part of The Problem. Their imitation rock music, and the flaccid music of other faceless bands with forgettable names like Sherbet, Pussycat, Sailor, have turned the radio a washed out shade of beige. Where giants once trod is now the kingdom of a flabby and emasculated rock aristocracy, and the heavy bands, the ones whose names are hand-carved in biro on a million denim jackets, don't have songs to change your day let alone your life. It's a dreary world of Light Entertainment. We're doomed.

The next morning I talk about it with my editor at the music paper *Sounds*. How do you describe something outside all the rock music tropes? Express the idea that a raw, half-formed racket, voiced by a caustic and hypnotic guttersnipe, attention grabbing even when it's boring, may be the Siren

call that, if we take the wax from our ears and ourselves from the mast, leads us forward to where we once were? The conversation is as much for me as him. He doesn't say much, listening with an increasingly bemused look, then tells me to do an interview. When I protest that they are too new, he points out I've been talking about them for 15 minutes.

McLaren makes me meet him first. It's a hot April London day. He sweeps into the café, a beanpole of pinkywhite pallor and exploding hair wearing leather jeans and leather coat over a pink nylon turtleneck, indifferent to the heat and humidity swirling through the room. Over cups of instant coffee he passionately unwraps his manifesto for creating a new music, a new movement, an audience for his clothes. It's anti-hippie, anti-drugs, against the status quo and against Status Quo. He's creating the future by mining the past, painting Tomorrowland images of leather Gene Vincent and peacock Little Richard walking gloved hand in hand through the riot-torn streets of Paris 1968. His enthusiasm for a new order is inviting to anyone bored with the current scene: me. As though granting a rare honour, he decides I can meet the band.

The interview takes place upstairs in the Cambridge Arms, a rundown pub on Charing Cross Road. We have a large worn-out floral carpeted room to ourselves. Steve Jones, Glen Matlock and Paul Cook are pleasant, somewhat naïve young men regurgitating Malcolm's manifesto. Johnny Rotten arrives midway with two girls. He sits some distance away, ignoring us, looking vaguely bored, face soft-featured as he talks quietly with the girls. A safety pin dangles from a thin gold ring in his right ear lobe. He's in the ripped up sweater again, with a large crucifix safety pinned to the chest. No one says hello. They continue talking about him in the third person, as if they're still deciding if he's in the band. Finally I ask John a direct question. In the fraction of breathing in, he changes. Rage blasts from his face in a laser-narrow nova. Aimed. At. Me. Later, when he gets used to the press, John's invective is slower and delivered with stiletto finesse. This is a face snarling machine gun bullets and a death-ray glare.

"I hate shit. I hate hippies. I hate long hair. I hate pub bands. I'm against people who just complain about *Top of the Pops* and don't do anything. I want to change it so there are bands like us."

Hatehatehatehatehate. It's riveting, intimidating and funny, and from the corner of my eye I see McLaren staring at him with a mix of detachment and wonder, both a scientist observing an experiment and an impresario thrilled at what has come into his grasp.

Does Malcolm have any idea how lucky he is? How rare this is? Without this creative misanthrope all he has is a barely competent band and a head full of plans. Already this rage-filled young man, sitting bound and wired like tight electricity, is doing things with his ideas that McLaren's never dreamed of. John isn't content just to wear SEX creations. He personalizes them into something easy to mimic. It's John who makes safety pins part of the look — a symbol so simple that becoming a Punk is as easy as opening your Mum's sewing box. John won't just repeat some slogans, he's got enough anger for the world. He can easily fill a reporter's recorder with energetic bile and mockery. As John's confidence grows it's hard

to tell whether he's inspiring McLaren or building on Malcolm's ideas. Which came first: "Only Anarchists Are Pretty" or "Anarchy in the UK"?

They start a residency at the 100 Club. There is no one else like them, four urchins looking for a lever to move the world. The room is low-ceilinged and narrow with the stage on the long side so that it feels full even when there's 40 of us watching — motley misfits escaping the suburbs and denim and the music that soundtracks it. They go to gay clubs that play dance grooves and follow avant eccentrics like Eno and Can or the aggressively modern Roxy Music and David Bowie. Until now they've been taking their style cues from these two. But as the Pistols keep improving we increasingly know we're heroes waiting for an epic, embracing new rules, new attitudes, new clothes. The irony is that almost no one can afford the SEX wardrobe. Instead we improvise with thrift store élan and art school finesse. When the zip on her jeans breaks, one art school girl fixes it with three oversized baby safety pins flauntingly pinned down the front.

In late May the contrast between what thrillingly feels like 1976 and bands that have been around too long comes sharply into focus when the Rolling Stones jet into London for six nights at Earls Court. Attended by Princess Margaret and a louche swirl of aristocrats, the Greatest Rock and Roll Band in the World is flabby and bloated, sapped by drug addictions and a belief that kings of the world don't need to care. Heretically, they sound old.

At Wembley Empire Pool on the other side of town strides another Rock Colossus. But David Bowie has alchemically turned his addictions and obsessions into performance gold. He's left the cocaine in Hollywood, moved to Berlin and concocted a muscular new palette from sinewy skeins of rock, funk, motorik and ambient. David debuts his new music on a stage bleached of colour, raised to the purity of white by incandescent walls of light, in front of which, dressed in monochrome and smoking Gitanes, he commands the audience. It's fire presented as ice, so modern, so *now*, that the Bowie clones dressed in their hero's old poses look moth-eaten. The Pistols audience is there, dressed to impress. By looking so new, so out of place in the audience, they form a timely connection to and thus a validation from the man on stage.

TWO

Cindy lies in bed nightly, transistor to her ear. Rhymes and mysteries whisper on the ether, warped by the distance from Luxembourg. Maybe tonight the DJ will walk through the wall and play her magic alchemies. At school everyone likes Yes or Deep Purple. She's an island in a sea of biro-carved denim, searching for jukebox poetry to call her own. Some nights she hears it… a mood, a secret alphabet… lodging deep inside her, like a strange flutter. Maybe it's an illness.

Debbie Harry watches from the wall, "*PUNK* Playmate of the Month." Cindy hasn't heard Blondie, but you can fall in love with bands before you even hear them. When you do, you love them forever. She knows about the New York groups from the music papers she buys every week. One day she sees a photo of Television and she's hooked. The look! Their names! They're instantly her favourite new band. She stares at the pictures, imagining

what they sound like. When she tracks down their self-produced single way over in Manchester, they sound perfect — like something that would make you shave off your eyebrows and catch a bus to an exciting life.

She knows what the Sex Pistols sound like too. She comes to London on the bus to see them. At the door into SEX her friends stop: step through the door and you're making a commitment. How predictable — as if they went to sleep at 16 and woke up 30. She steps through. "Roadrunner" plays on the jukebox — *Oh God!* Some of the Pistols are there and the shop assistant Jordan is a rubber-clad goddess from the future. It's magic. Two Punk girls window-shop the clothes. They're part vamp, part dominatrix, part something else. Cindy notes the stylish one with a Bowie thing about her and Cindy thinks, "I can become someone else completely. Become who I really am." She can conquer anything. It's printed on the label of her SEX "Anarchy" shirt — "Clothes for Heroes."

A hero needs a heroic name. In turning the young John Lydon into Johnny Rotten, Malcolm is just aping a showbiz tradition as old as entertainment. But the potential to wear or become a new identity, just by a name change, captures our imagination. Siouxsie Sioux, Billy Idol, Cindy Stern — we're all trying on a new *nom de hero* to see if it fits.

Against this, designer Jamie Reid creates a visual aesthetic so simple that every amateur thinks they can do it too. Mainstream rock design plunders art and history to sell glossy, sophisticated expressions of stardom. In contrast, Pistols art is crude, amateurish, proudly hand made, the lettering roughly cut from newspapers. They are like ransom notes in reverse. Instead of offering to return you to the safety of your world, they're going to kidnap you from it.

Whirling through our scene is John's friend Sid Vicious, a tornado force of an idiot savant. Every movement needs its poster boy and Sid eagerly fills the role, a goofy cartoon wielding a chain, easy to describe in broad strokes, spouting inflammatory declarations that neatly soundbite McLaren's anti-hippie manifesto. "I don't remember the Summer of Love. I was too busy playing with my Action Man." Perversely, he is smart and perceptive, but to have a starring role Fleet Street prefers a Punky village idiot with spiky hair and cut up t-shirt and dirty white brothel creepers. Cindy thinks he looks amazing.

When her job at the coal mine allows, Cindy takes the bus, six hours to London. She craves the Pistols. She likes their rhythmic purity and lyrics pushing her forward. With her cheap camera she snaps the charismatic Johnny: frozen moments of delight and vanity and contempt, as likely to play to the crowd as bite it. Everything to know about John is in his eyes, which are pale blue and alert. They can glow with affection, especially when talking with women, or instantly go cold with disdain or anger, or, as frequently happens on stage, reflect a vague detachment as he surveys the bodies in front of him.

THREE

On a sunlit June evening in the Nashville pub in Kensington, the second Punk band takes about 20 seconds to polarize the ghost-town audience,

scattering them before the jet-speed noise. Singer Dave Vanian is a charming little vampire in black. Ray Burns, the bass player, is subdued and almost anonymous. Drummer Rat Scabies gnashes at the audience between songs. Axe man Brian James sometimes finds riffs by slapping his fingers against the fretboard and humps his guitar into the speakers for inspired feedback endings. The sound is a sustained blur of noise and slam. It would be really impressive if the band didn't play to four separate rhythms.

They are called the Damned. This is their third gig. They don't rehearse because that might sap the music's energy. But this is a cul-de-sac and soon they change tack and become incredibly tight, full of short sharp shocks, another exciting band that hasn't spent ten years collecting self-importance.

On 9th July, the Sex Pistols play a "Midnight Court" at the Lyceum Ballroom off the Strand. These all-night concerts are popular, because the trains and buses stop running at 12 and it's a cheap place to sleep. They're third on the bill to the Pretty Things, a 1960s group who were once as deliberately provocative as the Pistols supposedly are now. In the perverse nature of a concert starting at 1 a.m., the Pretty Things are first, 15 years of playing together flowing in a show of effortless power. Backstage, Steve is terrified. How are they going to follow *that*?

At 3 a.m. we find out. The ballroom roof is open and a funnel of dingy predawn light is slowly blooming in front of the stage, draining the darkness just enough to reveal a floor full of sleeping shapes, oblivious to the Siren's call in front of them. Because what the Sex Pistols are doing is filling the large room with adventure. For the first time they sound and look like the rock band we want them to be.

Two things stand out:

Steve has changed his vocabulary of fuzz and noise for chains of clear, melodic notes. His timing and attack are impeccable; there's a sort of elegance to his playing.

John is electric. Draped from the mic stand in a cafe-singer shirt and a loose black tie, he stares hard at the silent shapes. If nobody claps he's wasting his time. He hotwires the first song. A few people clap. Dynamo eyes drill into the dark. They play the next song, and the next, the songs that reject the world he can't control and magnify the one he can. The audience isn't there. He moves less and less, becoming more focused, more necessary, more John Rotten. Energy crackles off him. He smokes a cigarette while he sings. In the middle of a song he shoves his right arm straight forward, hand in a fist, the unbuttoned cuff falling away to show raw cigarette burns on his arm, and in a fluid mechanical motion that's almost on the beat *takes* the cigarette from his mouth with his other hand, *swings* it in an arc, *grinds* it out on the back of his fist, *throws* the butt over his shoulder, and sings the next verse.
Shock. Denial I just saw that.

I push it away. It's too uncomfortable and emotionally complicated for my agenda of persuading young people that this is their sound, as fresh

as this week's news, ignoring what indeed is this week's news. How do you seduce a nation by describing that?

Eleven days later the Sex Pistols return to the Lesser Hall, a small auditorium nestled in the roof above Manchester's flagship Free Trade Hall. The first time they played, what would become the city's royal court of Punk bands had turned up. This time they bring their friends.

It is organizer and support band the Buzzcocks' first gig; four guys who stepped out of the audience, barely a glint of charisma between them. Only guitarist Pete Shelley looks Punk-star sharp: tight pink Levis and a Buzzcocks tee, Converse sneakers and jet-age shades. The top half of his red £18.49 guitar is snapped off. The attitude is in the music, jotted down details of a world that doesn't make sense.

The chorus of one song goes "Boredom, boredom." Howard Devoto kicks and punches the air, the Boston Strangler singing the dance of romance. Shelley isn't even bothering with the concept of a middle-eight, let alone a solo. But soon he begins to open out. By the time they fire up a high rev version of the Troggs' "I Can't Control Myself," he's performing the difficult trick of making minimal chord progressions and two note solos sound melodic. They finish and the band leaves the stage, except for Shelley who is conducting a feral feedback solo. He won't stop. He unstraps his guitar and throws it at the amp. He holds it in his hands and moves it to the squalling noise. *He won't stop.* Devoto comes out of the wings and pulls the guitar from him. He pulls it back. Devoto grabs all six strings and yanks. They break. Shelley props the screaming guitar against the speaker and runs off through the audience.

While equipment is changed, the capacity audience poses. The David Bowie lookalikes all look like their skinny hero. One trendsetter sports a classy homemade Sex Pistols t-shirt. At the back are six rows of very straight looking people who sit there vacantly all evening, even those who loathe it.

The Sex Pistols are greeted with a wild ovation. John beams. Then Steve jumps to the front of the stage and starts ripping open "I Wanna Be Me," legs apart, swinging his hips from side to side. The months of experimenting and learning and playing have in one week gelled the band into a confident unit that knows it is good. Paul and Glen drive a muscled rhythm over which Steve fuses clusters of clear ringing notes and scything sawtooth fireworks, ending songs with dive bombs of precise, searing feedback.

A tall skinny guy starts a high-speed robot zigzag up and down the aisle. A Neanderthal in stringy hair and leather is bellowing "Stooges!" and pounding seats to oblivion. As the band blast into "New York," another long-haired guy comes leaping down the aisle, each bound taking him about four feet into the air, his feet somewhere around his ears. There's a delirious feeling that nothing is forbidden, everything is permitted.

Then. With no introduction there's a repeating guitar figure over cantering drums. This is new. John watches the crowd. It thunders into the verse. He pulls the microphone to his lips.

"I am an antichrist, I am an anarchist…"

It keeps unfolding, better than their other songs, bigger, smarter, with swaggering riffs and an anthem beat, the band nimble and relentless. John stands still, dominating the song, the words sharp, telling a story both clear and cryptic, a bombsite vista of our tattered country. It's easy to feel the singer's truth. We're alert, waiting. What comes next?

"Anarchy, in the UK, coming some day, maybe…"

If rock and roll is optimism born in plenty, this is a Ballardian vision Elvis never imagined. It may be the song that frees us from the past.

McLaren stands at the back of the hall staring at them, looking a bit shocked, perhaps realizing for the first time that their ambitions are different from his.

"… is this the UDA, or is this the IRA, I thought it was the UK, or just another country…"

His mouth drops open.

In the time it takes to play it, they change from a good band into a great one.

At John's encouragement the space in front of the stage fills with wildly bouncing people. By the time "Problems" blasts to a close, the crowd is screaming.

For an encore, John tears up his shirt.

Three weeks later, a band called the Clash invites a small audience to their clubhouse, Rehearsals Rehearsals. It feels a bit like a church, with whitewashed walls and a cityscape fresco behind an altar of painted pink amps. Manager Bernard Rhodes hovers in the corner like Hitchcock in one of his movies. We wait. Expectant. Five guys march in purposefully in single file, led by Joe Strummer, who has abandoned his popular band the 101ers for this unknown quantity. Their clothes are spattered in paint like Jackson Pollock paintings. There are three guitarists and Mick Jones, the one with a shaggy nest of black hair and high cheekbones, has made striped pants by pouring paint down the legs. They plug in and count off. A cannonade of rat-a-tat rhythm. The words are ripped from the news. Before it can make sense it's gone. Then another song. And another. An hour's worth of music in 30 minutes. They have a neat trick of collapsing the music to a single guitar, and two bars later thunder in on a crack from Terry Chimes' bat-sized drumsticks. The band erupts in the small space. Guitarist Keith Levene literally runs up the wall. Bits of paper to show bassist Paul Simonon where to put his fingers keep falling out of his guitar neck. The action-painting clothes are a superb metaphor for the overwhelming delirium of pinball-frantic music and motion. I'm not sure what this is, but I know I want more of it.

FOUR

It's become a movement — a small club for misfits, outsiders and the sexually ambiguous. What to call it has been an ongoing discussion. If we're all about The New — new music, new clothes… a new brain — don't

we need a new name? Punk already describes the glorious noise made by 1960s American primitives like Count Five and ? and the Mysterians. We can't use that. McLaren starts calling it New Wave, after the French cinema auteurs. But in the unspoken codes that drive movements forward, new fans decide joining New Wave is a wrinkled white shirt and a loosened tie; that it's enough to change your clothes, not your mind. McLaren's having none of that. We settle on Punk.

The tipping point comes in late September at the 100 Club Punk Festival. It's full. *There's hundreds of us!* Picture this: Gaye Advert, next year's Punk pinup, scoop neck t-shirt proclaiming love for *IGGY* inside a heart, heavy glitter eye shadow on eyes closed in transport. Against her, a boy in bleach-stain spattered black t-shirt with the sleeves cut off. Wedged next to him the other Punk pinup Paul Simonon: white jeans, striped sailor t-shirt, beige jacket with a razor blade on each lapel. Repeat all over the jammed sweaty club — people who are beautiful, ugly, sublime, comic, all of them adapting the parts of Punk that talk to them. It's a significant moment, and around the edges you can see some of the hipsters from the first 50 thinking, "This scene has had it," and soon they will be gone, looking for the next underground.

Four people have climbed out of the crowd and called themselves Siouxsie and the Banshees. Guitarist Marco Pirroni is concentrating hard — because he's the only one with experience. Sid Vicious has convinced himself he can play drums. He's been telling everyone that it's easy. A tornado of concentration, uncontrolled but rigorous, he hits them with both sticks at the same time — boom! splat! boom! splat! Steve Severin wants to be on a stage before he's 21. That's next week. He picked up a bass yesterday. His girlfriend Siouxsie has traded her rubber fishnet nudity for a black jacket and lookatme eye makeup. Her black hair is flecked with red flames. Over the motorik boom! splat! drone she intones "Knocking on Heaven's Door" and "The End" and then "The Lord's Prayer." It's not like the other bands — they play daytime music. She's talking about nighttime, when monsters call out the names of men. She's nervous. We will her on. When she sees everyone enjoying it, she starts to enjoy it too. This is what makes Punk so exciting. Someone has grabbed their future by the shoulders and given it a good shake.

Near the end of the Damned's set, Dave Vanian stops the group mid-song and emotionally announces that someone has thrown a glass. It's hit a column, shattered, and blinded a girl.

An ambulance is called. Police arrive. They mill around the doorway, nine young men in blue waiting for orders. Twenty feet away, Sid Vicious, Mick Jones and I watch. Their officer talks to the club manager, then his men. Five police turn and march briskly to us, surround Sid on each corner — two in front and three behind — and without a word force-march him at speed to the door. One of them looks about 17. Sid shouts and starts a panicky fight to get free. They tighten grip and march him out. It's so fast they're moving up the stairs before anyone reacts. Then we swarm after them. Everything is double speed. At the head of the mob the tall, authoritative writer Caroline Coon is politely saying over and over to the back of the policeman in charge, "Excuse me officer, what is wrong? Excuse me officer please explain yourself. Excuse me officer

why is he being arrested?" In 1967 she had founded Release, a free legal advice agency for young people, and is an expert on search and arrest. The officer ignores her. As they reach the street, Caroline puts her hand on his shoulder and in an imperious voice commands, "He didn't fucking do anything!"

The officer points and says, "Right. Get her too," and she and Sid are quickly bundled into two cars and they are gone.

An hour later Caroline returns to the club. She has been released without charge. In the station, on the other side of a room divider she could hear the police repeatedly taunting Sid, banging his head on a table whenever he talked back.

The next morning he is arraigned in Marlborough Street Magistrates Court, a high-windowed hall of solemnity and stained oak. His face is a mass of bruises, with livid yellow-purple rings around his eyes. He is still wearing last night's torn t-shirt and jeans, but the condom tied to a belt loop has gone.

The court session is a chilling experience. Most of those appearing are black, arraigned on "suss" laws, which give police the power to stop and arrest people on the "suspicion" they are going to commit a crime. The judge decides to make an example of one youth with 18 "suss" charges and sentences him to three years.

Sid is remanded to a juvenile detention centre. Bail is set at £1,000.

Because of the illegal arrest and brutality, I guarantee his bail. The hearing comes a week later. He sits in the dock in a cheap grey suit, cowed and small. There are still bruises on his face. Both the police and I testify under oath. Our versions of events are very different. The prosecuting Queen's Counsel keeps suggesting that I'm wrong. Smiles as if I'm irrelevant. The important thing is to keep talking and not dry up. Oddly, it starts to be fun finding different ways of saying the police have their facts wrong. The judge summarizes. Interpreting the codes spoken in court, he thinks the police are lying. Sid is bailed. The trial is set for next year.

On 23rd October, the Clash present "A Night of Pure Energy" at the ICA. Before the set Mick Jones says that earlier in the week he saw a Punk wearing a black plastic bin liner. We can't stop laughing, and in the afterglow he says one of the most prescient things anyone in the scene has uttered.

"You know, there's a capacity for real stupidity in Punk. It might turn into everyone in bin liners."

The stage is a platform set up near one end of a big gallery space, wide and low. About 30 people watch them charge into "White Riot" and in the second verse Patti Smith leaps onto the stage, dancing in abandon, face ecstatic. Paul Simonon leans right into her and glares her off his stage. Afterwards, she whispers in his ear, takes his hand and pulls him out the door, Paul looking back with a delirious grin as they disappear into the night.

Joe wants to visit Guy Stevens. It's an odd suggestion. Guy is the forgotten producer of Mott the Hoople and has a reputation for extreme music passion roped to mental instability. We take the Tube, Joe oblivious to the passengers silently staring at his navy boiler suit with the reggae phrase "Under Heavy Manners" stenciled up one sleeve and the front covered in studs in ranks like chain mail, which he's painted bright blue.

Guy's room is empty except for hundreds of records stacked against one wall. On the floor opposite a small Dansette record player is blasting Jerry Lee Lewis *Live at the Star Club*. In each chipboard-papered wall there are several large holes. A naked hundred-watt bulb makes everything too bright.

Guy sits on the dirty nylon carpet leaning against a stack of records, all A-bomb hair and wild enthusiasm, glittering eyes moving to a private beat. Joe crouches in front of him. They talk rock and roll, priest unto priest, Guy ranting against the false gods, fuelling his righteous fervour with sloshes from a vodka bottle, finger stabbing at the Dansette and shouting "*THAT'S* rock and roll!" The record skips, and with an enraged scream Guy hurls the half-empty bottle at it. It bounces off the record and into the air and, as the needle scrapes through Jerry Lee's piano, falls into a ragged hole in the wall above the Dansette. Joe composes a carefully neutral face and turns back to his host.

"Well Guy, I think we should go now."

Guy's tortured screams follow us down the stairs. We pass a young executive in a pinstriped suit coming up who conversationally asks as he passes, "Is Guy having a bad night?" Joe explains the visit. He has been auditioning the band's favoured producer for the demo session Polydor Records is arranging.

Continuous support band to the Clash is Subway Sect. If Punk is an attitude, then they are the ultimate Punk band. Dressed in their day-job grey slacks and sweaters and white shirts, they are the most fashion unconscious musicians I have ever seen. Guitarist Rob Symmons wears a short sleeve shirt buttoned at the neck and has the guitar strapped up high across his chest. It is the most un-rock star pose you can imagine. Is this song title a clue? "We Oppose All Rock 'n' Roll." During one song the singer Vic Godard steps off the stage and watches the solo from the empty dance floor. At the Royal College of Art he reclines on the stage on one elbow while the band play. During a guitar solo he pulls a white handkerchief out of his pocket and wipes his nose. I'd call it Dada but there's a sense none of this is thought out, it just... is.

On Guy Fawkes Night, the Clash host "A Night of Treason" at the Royal College of Art — a crucible where previous art movements have shoved the world forward into Now. The halls and backstage rooms fizz with plots to start bands and plans to watch the dawn together. It's easy to tell the fans amongst the students; they've been taking scissors and paint to thrift shop clothes and trying on new identities, like Adrian Thrills, who has named himself after a Clash song celebrating the hours that fill the weekend, because "*Monday's coming like a gaol on wheels.*"

I've now seen the Clash about nine times. Joe Strummer has a headful of something to say and their music is a template in continuous motion: forged, fashioned, polished and double-timed with ambitious ruthlessness. They're a gang against the world, charged with messianic zeal — the Clash is a thought, a look, a choice. A way to live. Joe has buttoned it up in a soundbite: "Like trousers, like brain."

The concert space is large and high-ceilinged, with the biggest stage the band has ever used. They fill it with hypersonic mayhem and kinetic shapes. If they play fast enough they'll break the sound barrier. If they move fast enough they'll defy gravity. It's every bedroom rock star's fantasy of what a great band looks and sounds like.

Ten days later, after two months out of London, the Sex Pistols play in the basement of Notre Dame de France, a beautiful, almost invisible brick church off Leicester Square. They're late. The film *The Texas Chainsaw Massacre*, banned in the UK for some years, has just been given clearance and they are all at the cinema. When they arrive, they're wearing "I Survived" stickers like badges of honour.

They are being filmed for a London TV show and the room is full of silvery bright light. The capacity crowd is an interesting mix of the elite, the converted and the curious. Outside another hundred are trying to get in. The Pistols have become popular, outgrowing the reach of the original people. The movement is expanding beyond control, growing through that friction between secret society and mainstream excitement. Ordinary people, the ones from the suburbs that the original followers were escaping from, have decided they quite like this racket. Eight weeks is a lifetime.

The area in front of the stage is a seething, pogoing sea of exuberant male youth. Around the edges stand some of the original misfits. They look downbeat. There's no sense of intimacy anymore. No centre. People seem to think it's going to go somewhere — become something meaningful and those other silly attitudes about changing things. That's fine for art school arty types but then it leaks out into the sunlight. Now it's guys with plastic sunglasses. Skinny ties. Writing "Punk" on their shirts, to let people know. Instead of ambiguity, everything's becoming straight. Once there had been only one place to be. Now there are lots of places. Places they don't want to be. It's time to leave.

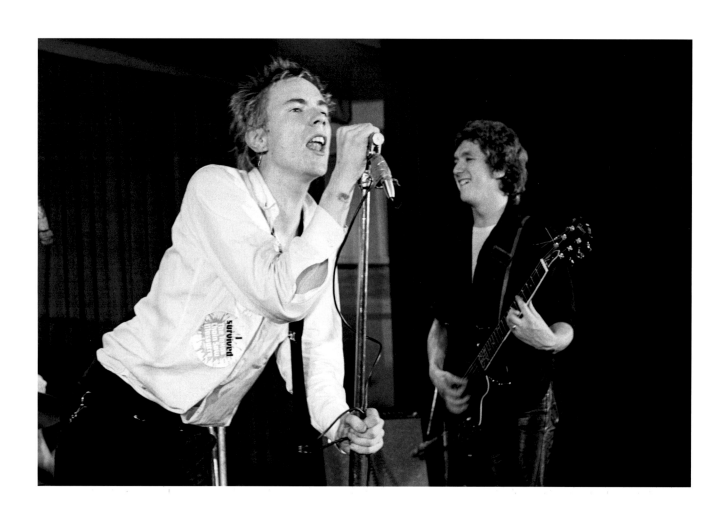

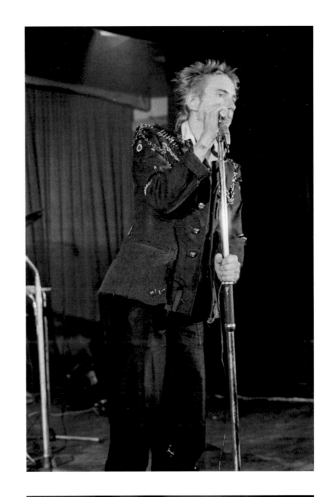

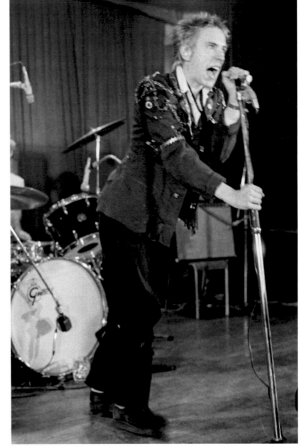

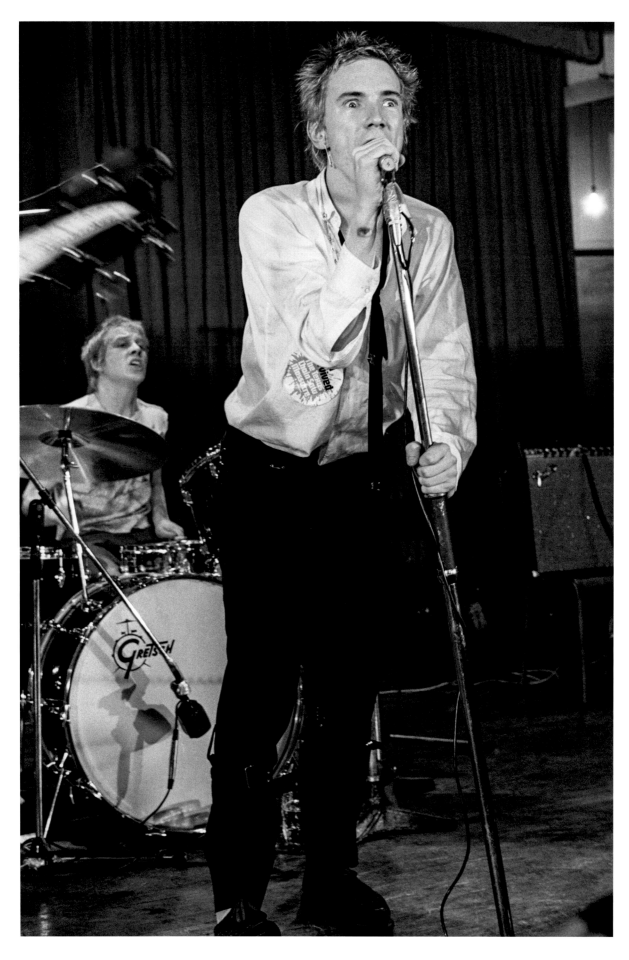

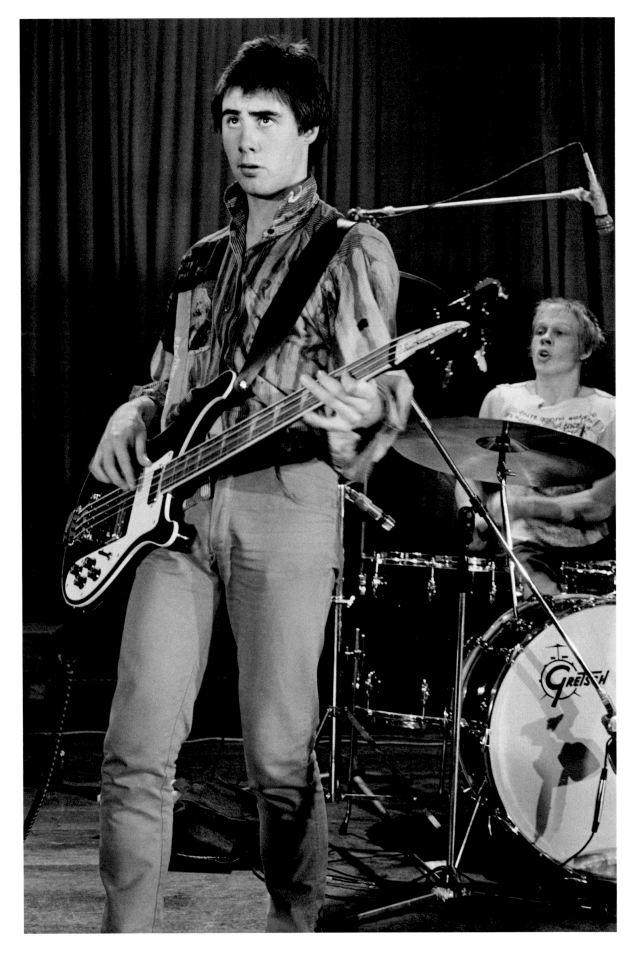

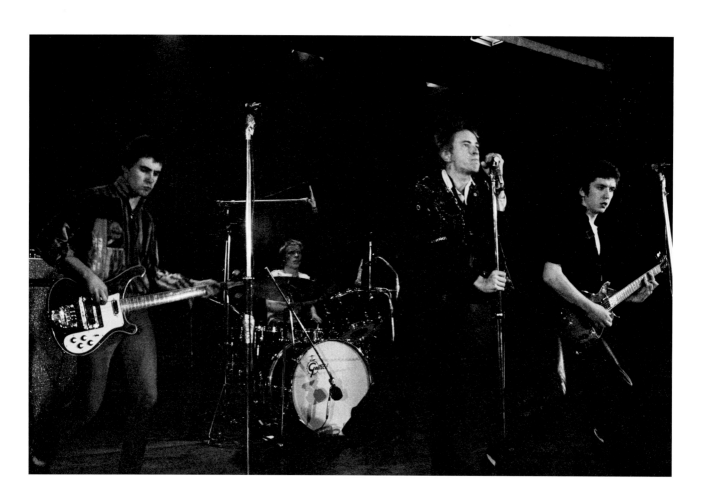

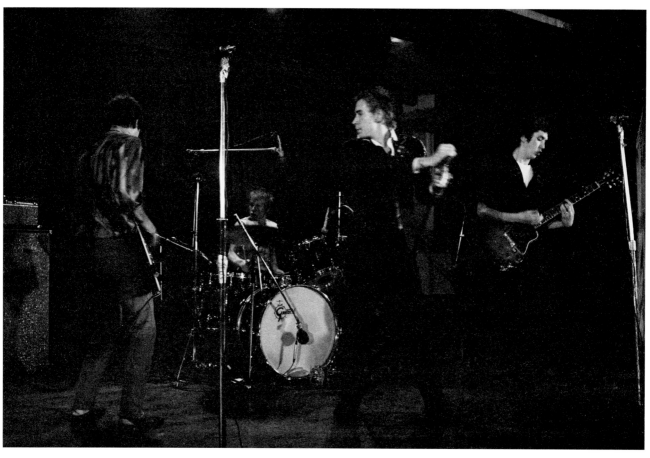

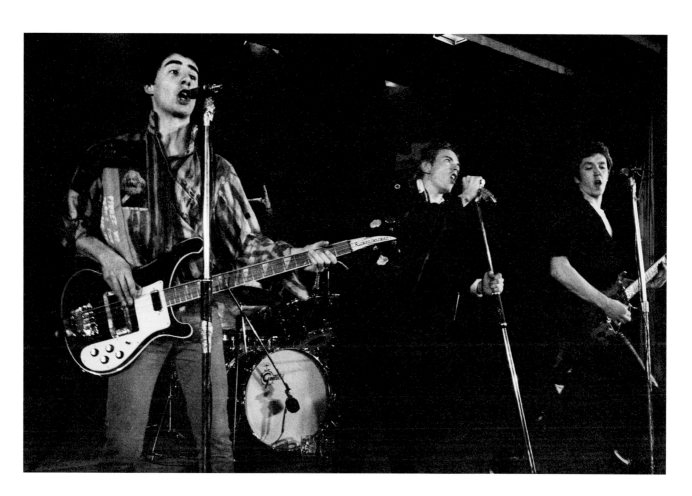

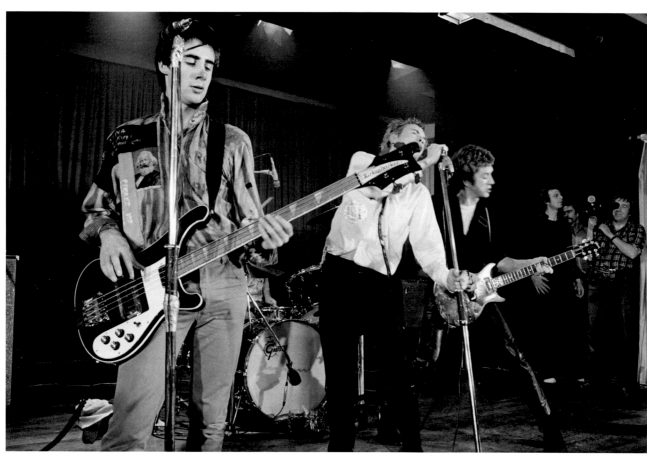

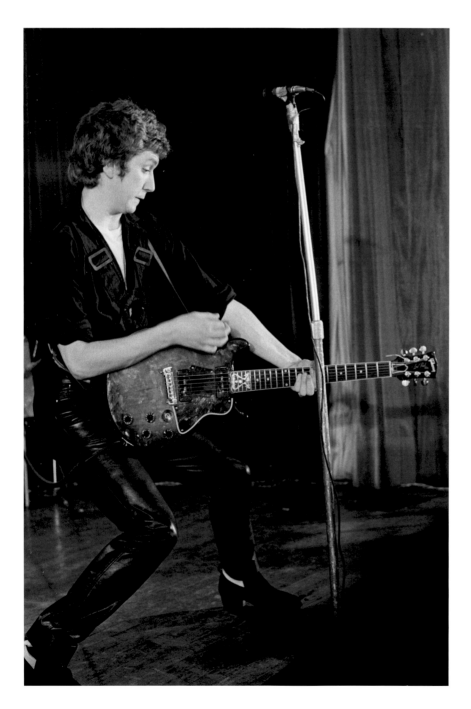

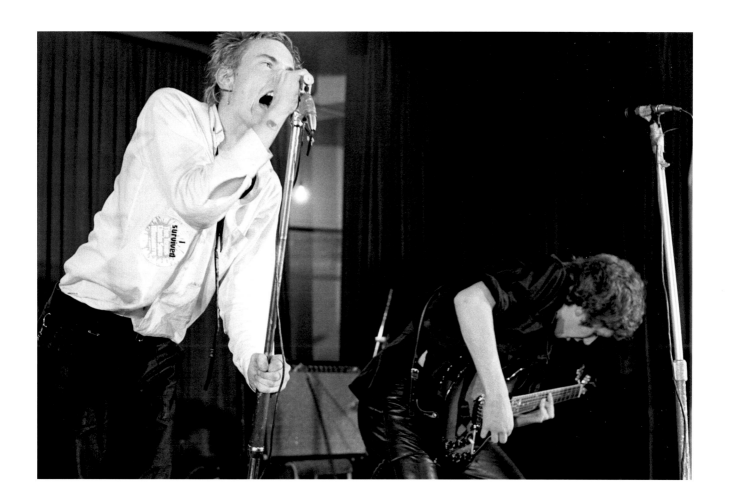

16. John Rotten and Steve Jones, Notre Dame de France, London, 15 November, 1976.

The Sex Pistols were being filmed for TV programme *London Weekend*. The film *The Texas Chainsaw Massacre* had just been released after several years of being banned for its violence. The group had seen the film immediately before the gig and came in wearing large "I Survived..." stickers.

18. Paul Cook and John Rotten, Notre Dame de France, 15 November, 1976.

19. Glen Matlock and Paul Cook, Notre Dame de France, 15 November, 1976.

20–1. The Sex Pistols start the show, Notre Dame de France, 15 November, 1976.

22. Despite Punk's anti-rock star sentiment, Steve Jones was every bit the guitar hero, fusing clean notes, feedback and in this case, running the mic stand down the fret board. Notre Dame Hall, 15 November, 1976.

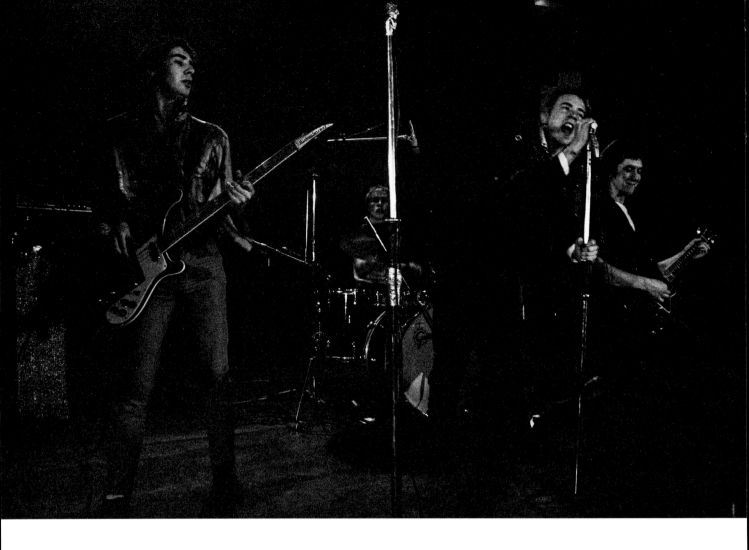

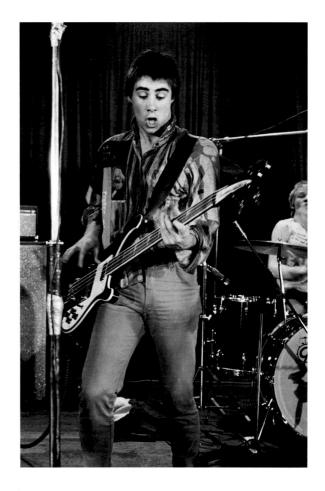

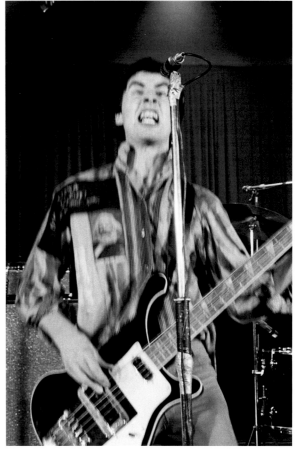

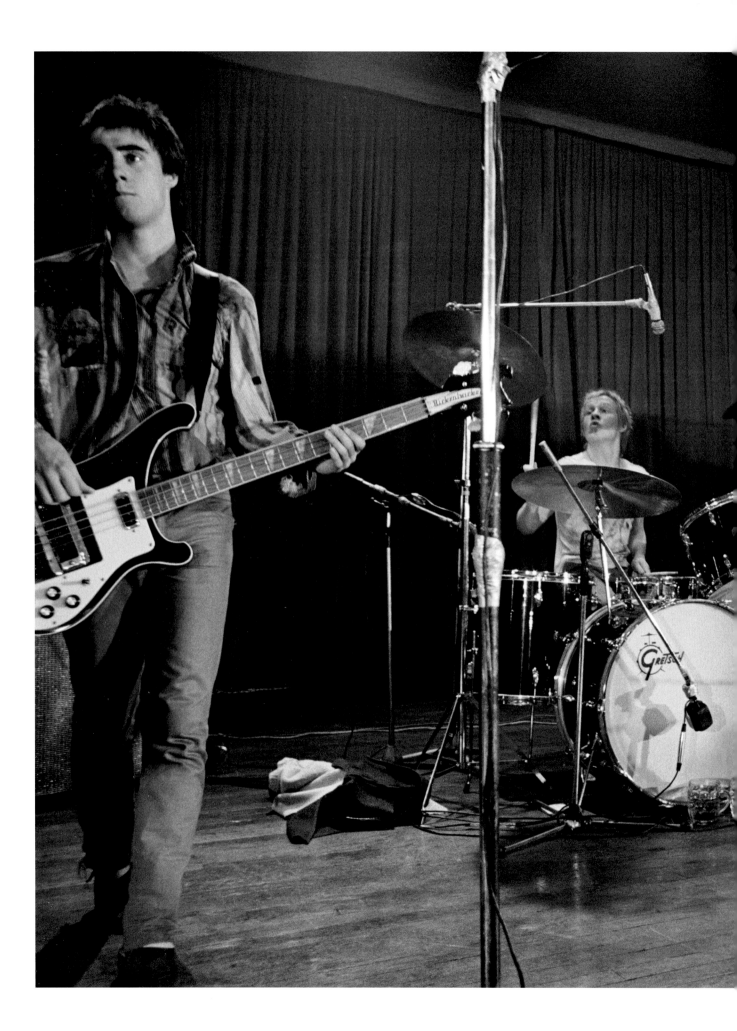

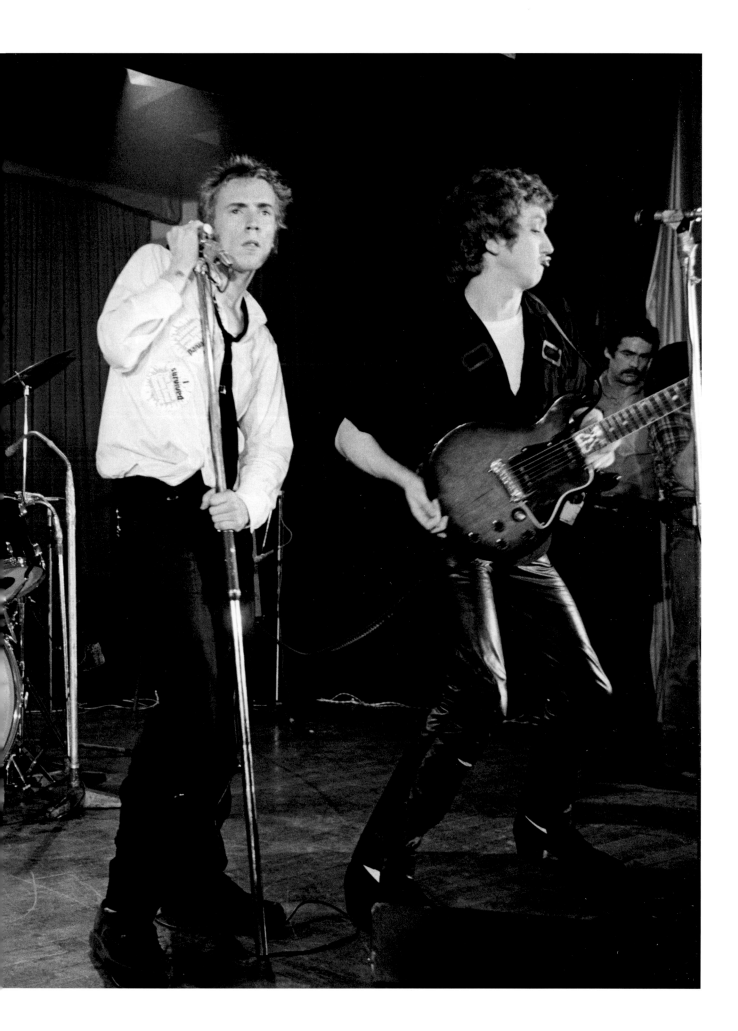

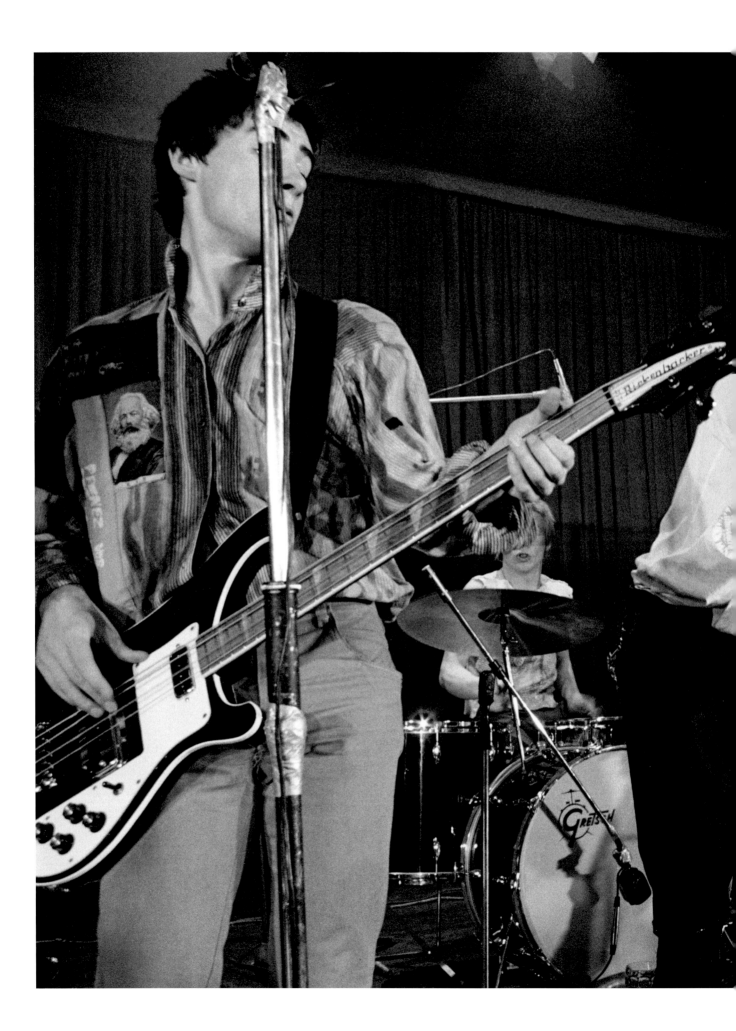

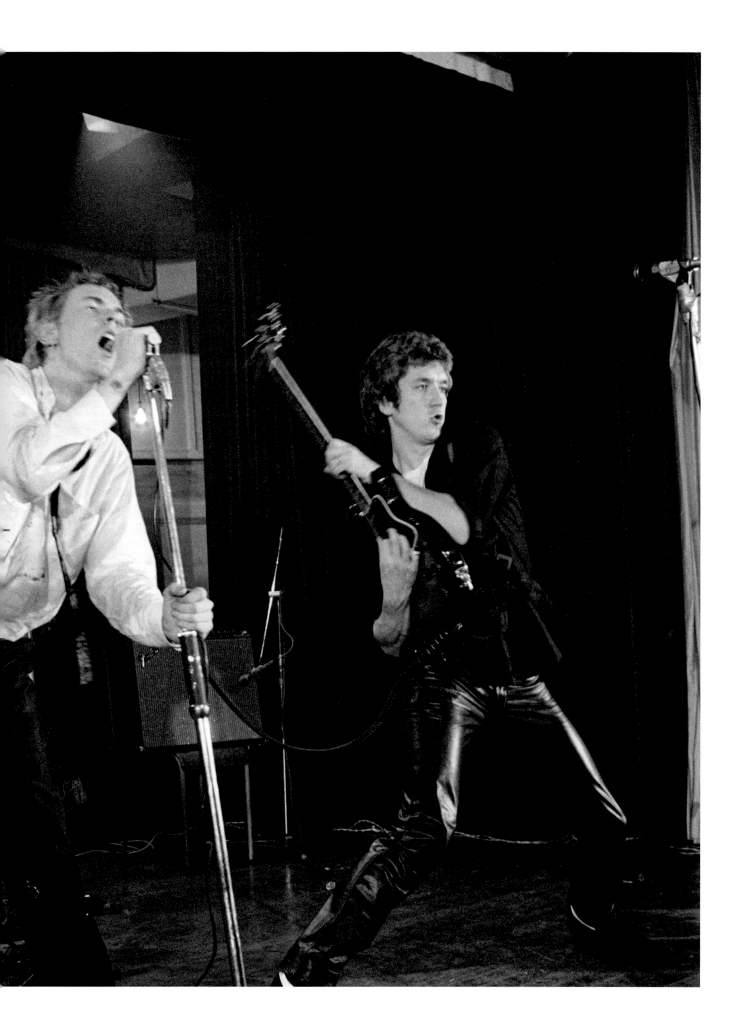

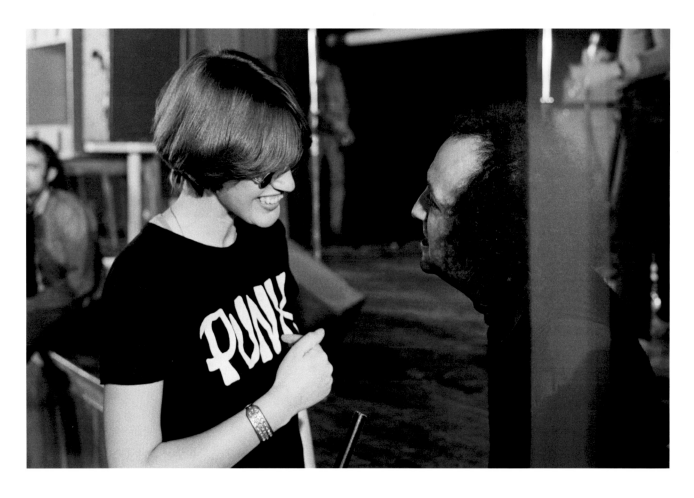

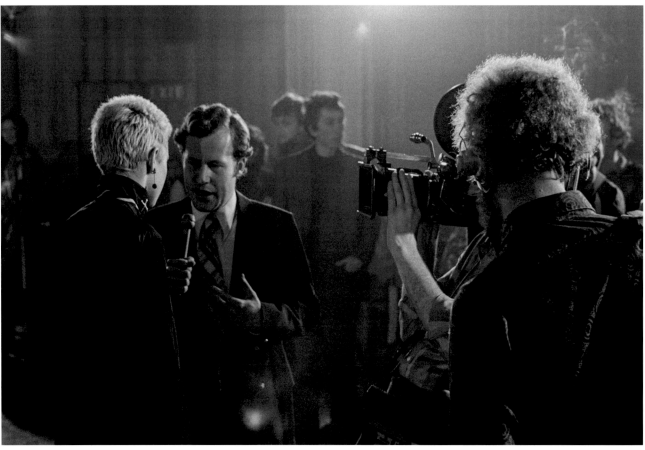

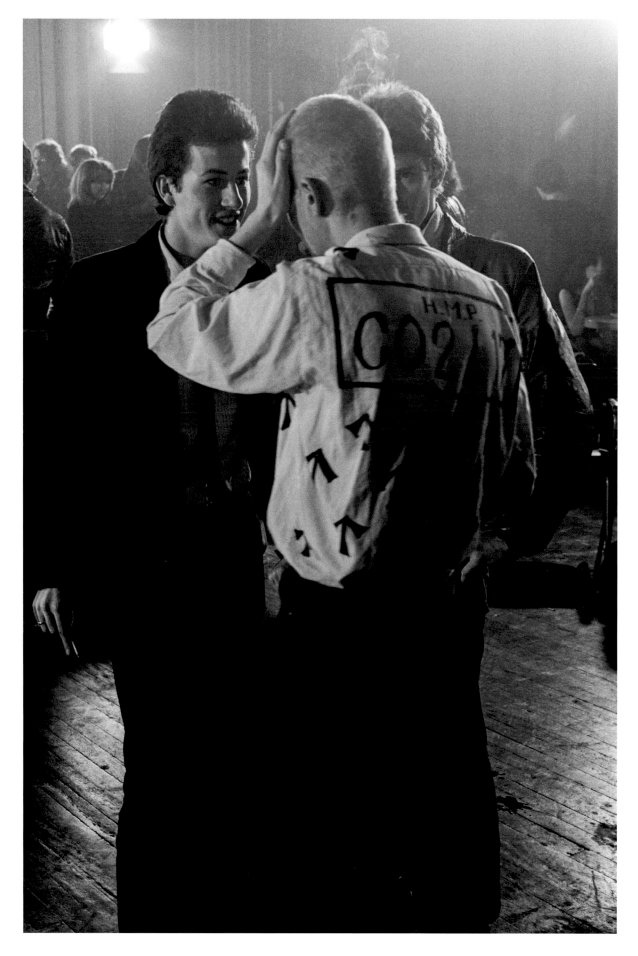

31

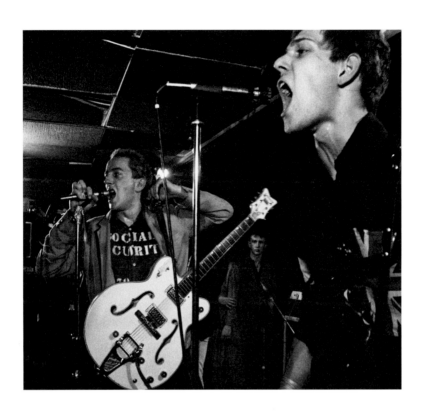

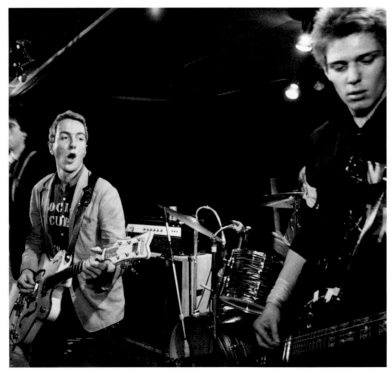

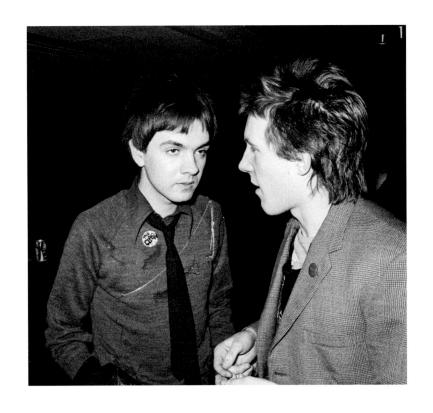

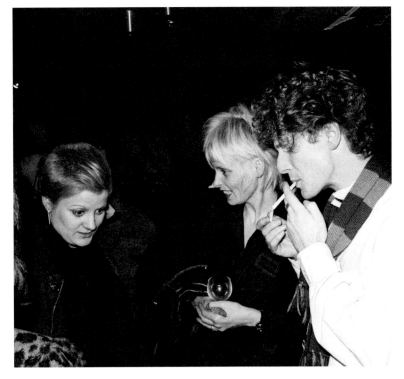

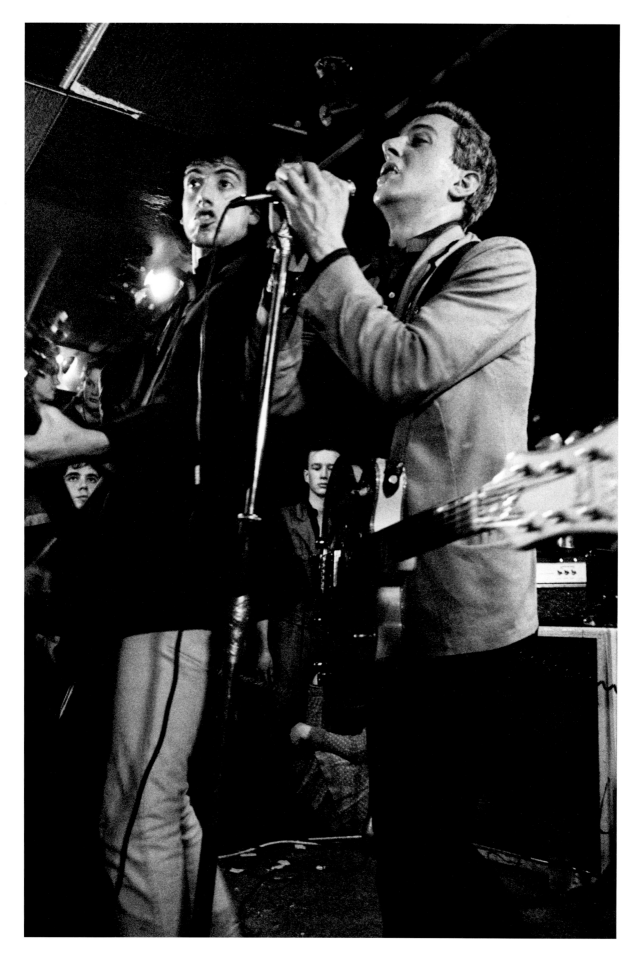

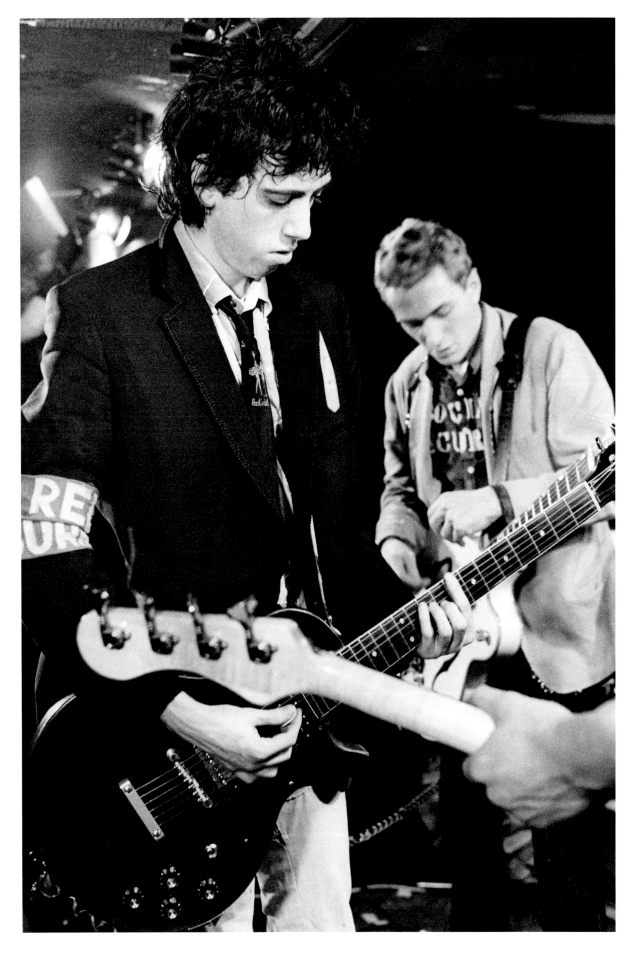

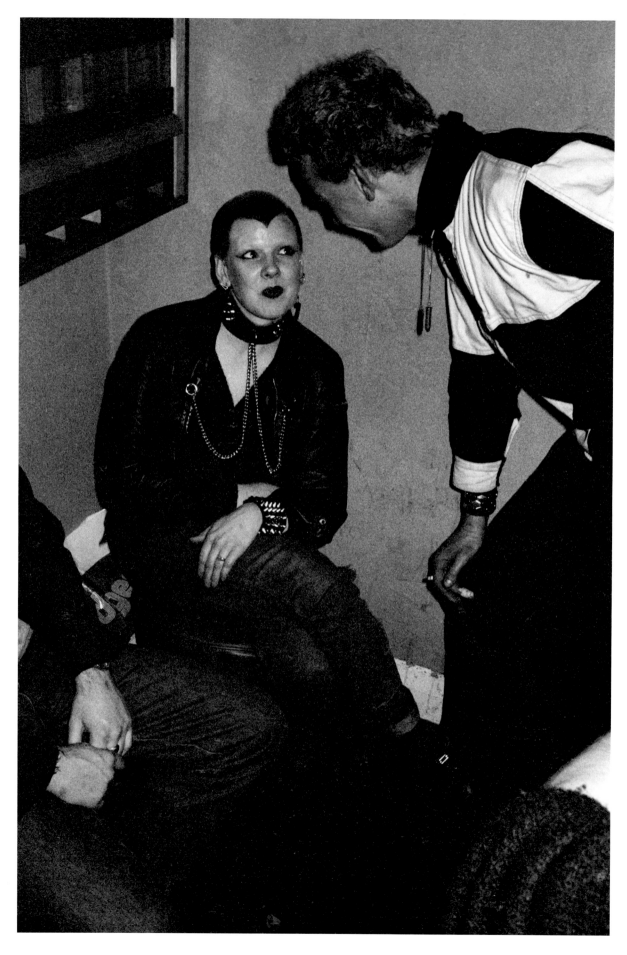

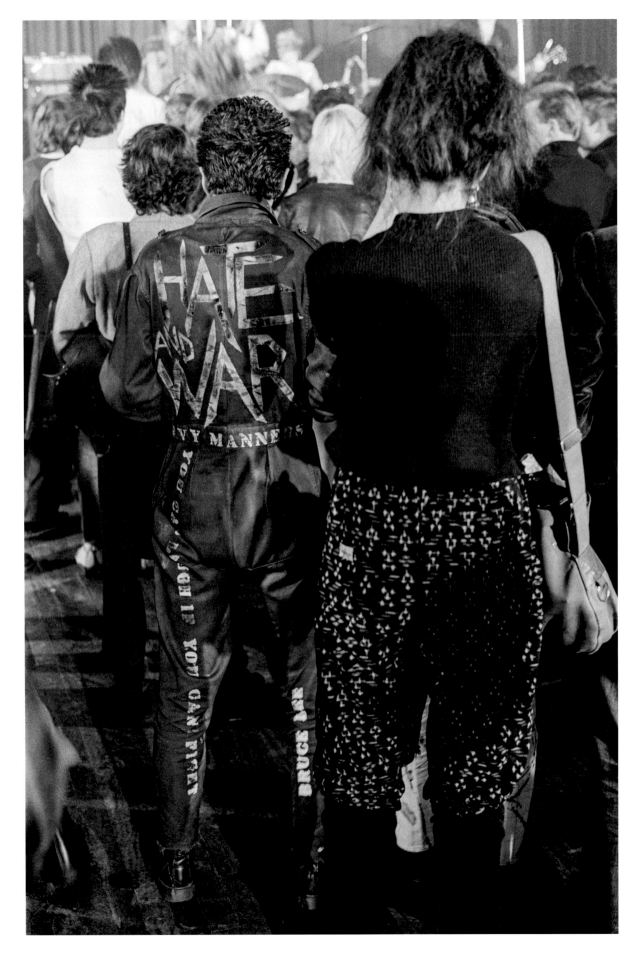

GENERATION X WILL NOT BE APPEARING ON FRIDAY 11th FEB. (THEY'RE MANAGED BY · PRATTS) SO INSTEAD THE WONDERFUL "CHELSEA"

ADM. 60p.

30. **TOP:** TV presenter Janet Street-Porter interviews producer Guy Stevens. Stevens was a key figure in creating, promoting and producing rock music in the 1960s. He would produce the Clash's *London Calling* album. Notre Dame de France, 15 November, 1976. **BOTTOM:** Siouxsie Sioux steps further into the limelight and does her first interview for television. Notre Dame de France, 15 November, 1976.

31. Roadent talking to friend. He had just been released from gaol and made a shirt with his prison number on the back. Notre Dame de France, 15 November, 1976.

32. Joe Strummer and Paul Simonon. The Clash formally open the Roxy on 1 January, 1977.

33. **TOP:** Kris Needs (Editor, *ZigZag*) and Mark P (Editor, *Sniffin' Glue*), Dingwalls, December, 1976. **BOTTOM:** Linda Ashby, Vivienne Westwood, Malcolm McLaren, Dingwalls, December, 1976.

35. Mick Jones and Joe Strummer, the Roxy, 1 January, 1977.

36. Soo Catwoman tries out a dark blue skinhead hairstyle, Louise's, November, 1976.

37. Joe Strummer watching the Sex Pistols, Notre Dame de France, 15 November, 1976.

38–9. The wall in Jonh Ingham's room. February, 1977.

41. Billy Idol in transition from brown haired Beatle-cut to peroxide Punk Apollo. The Roxy, December, 1976.

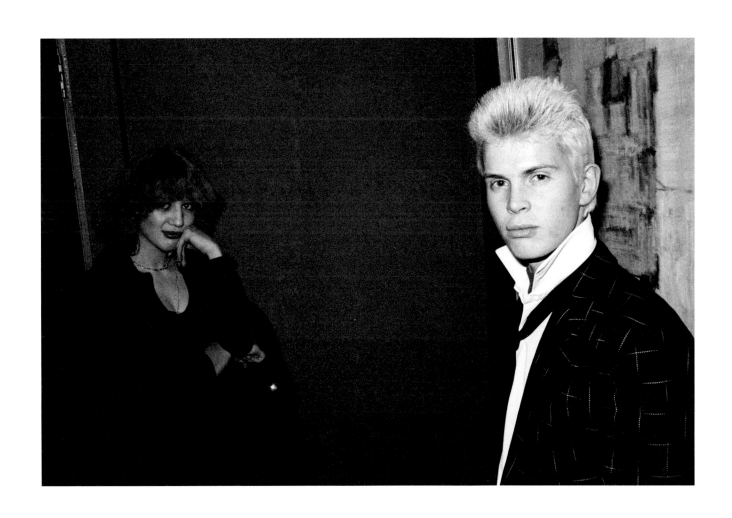

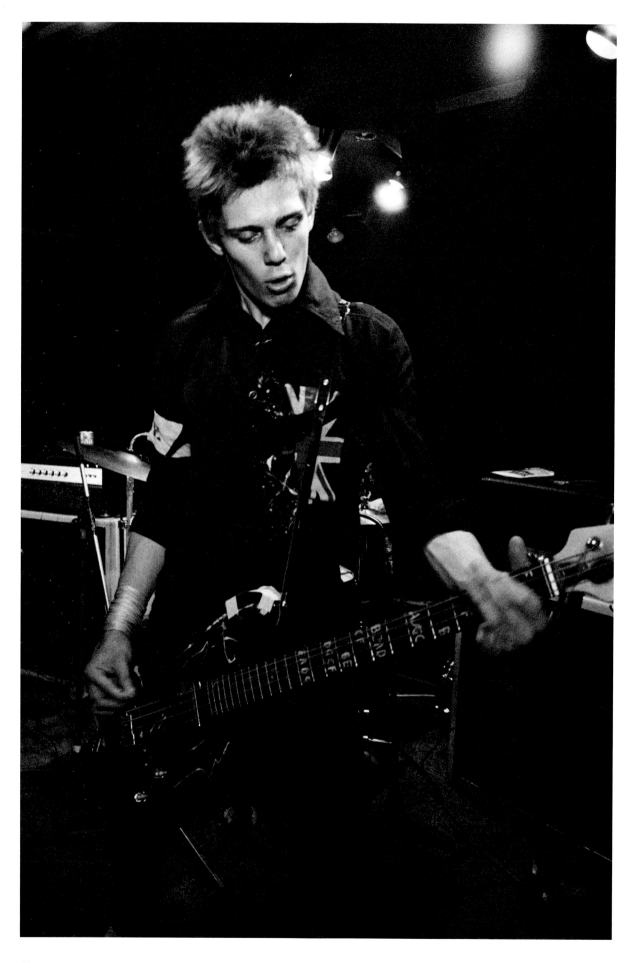

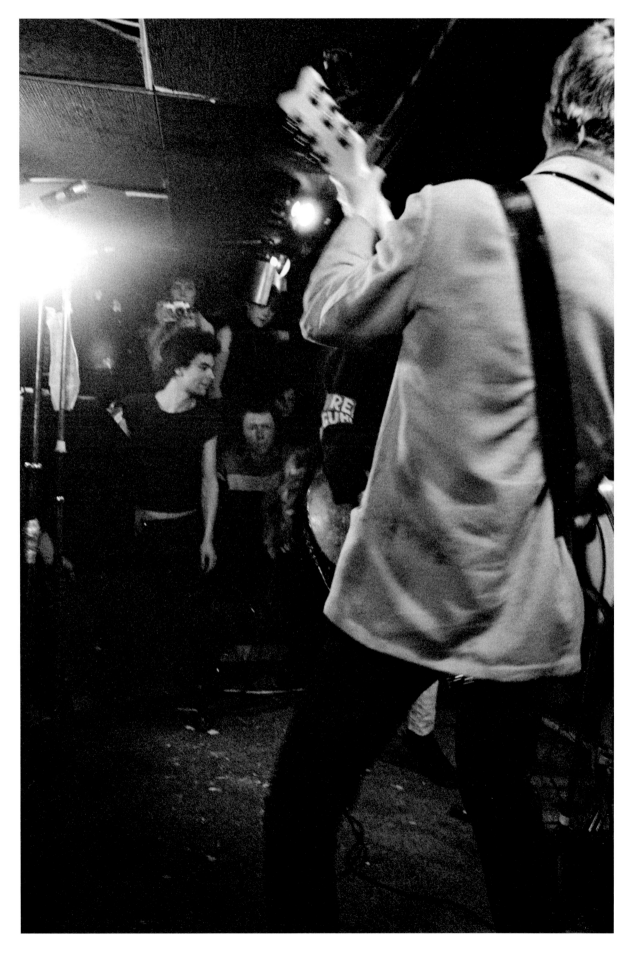

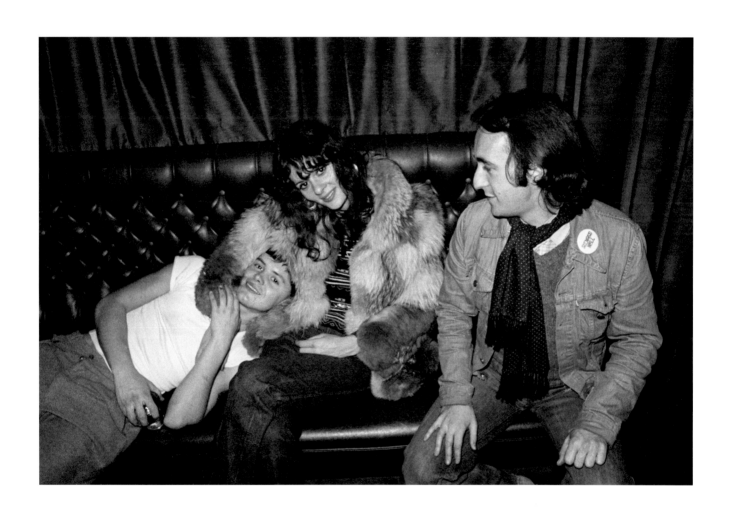

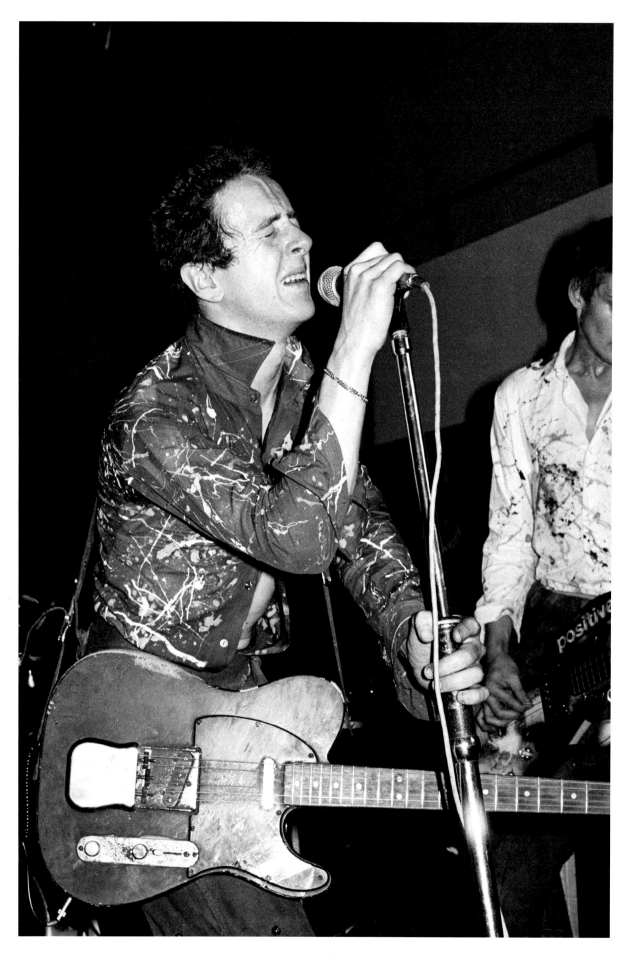

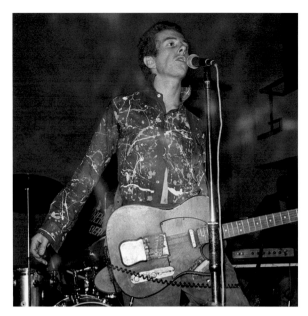

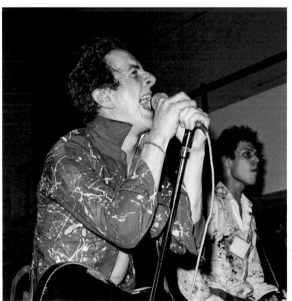

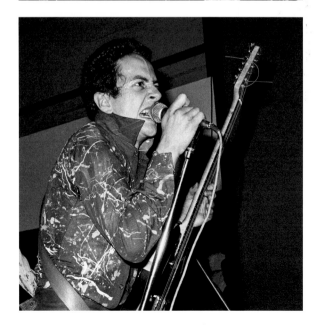

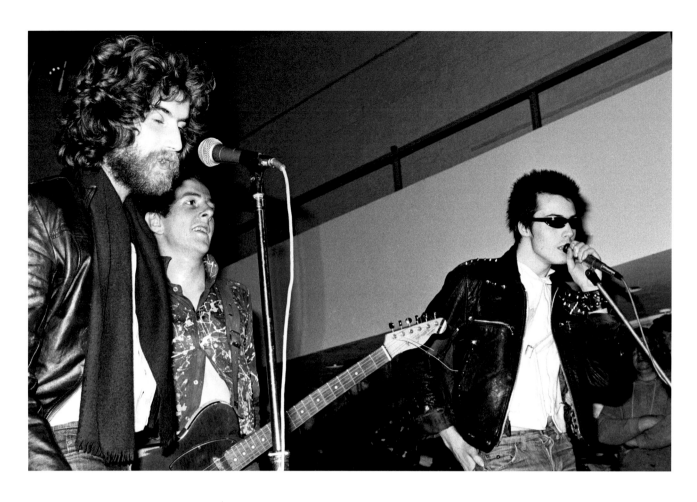

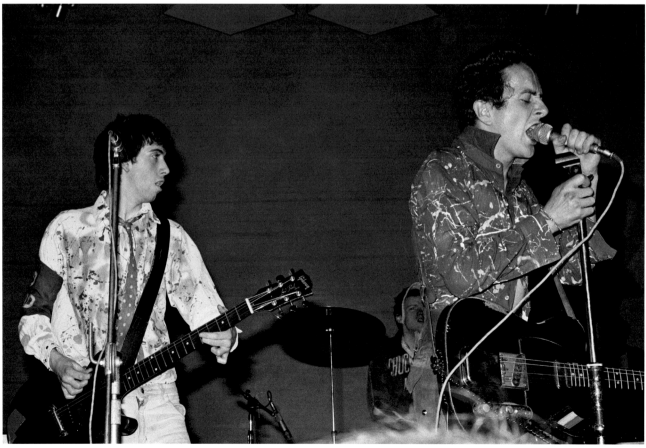

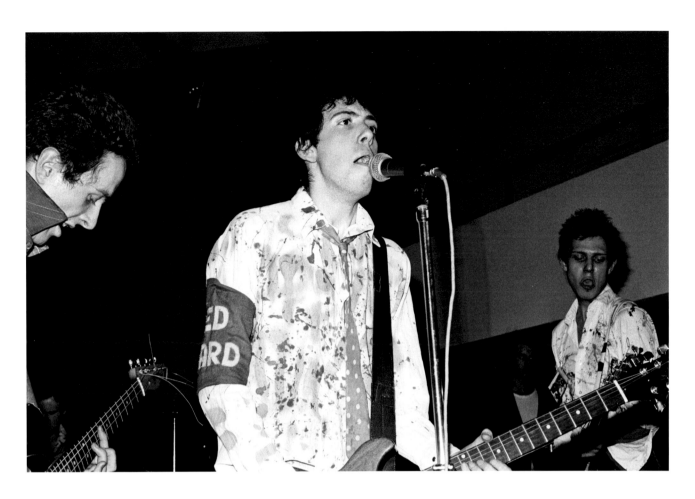

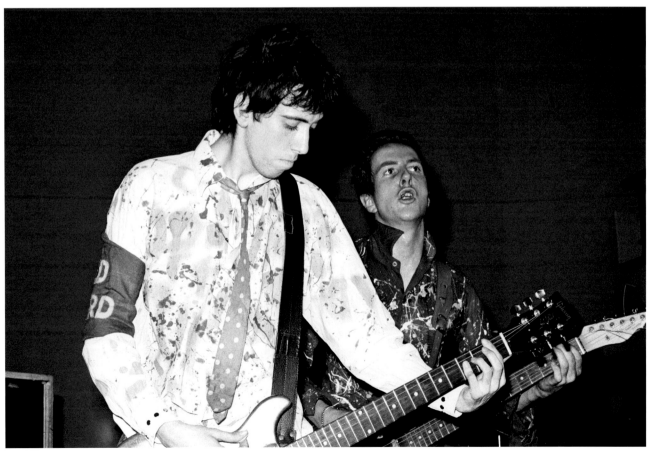

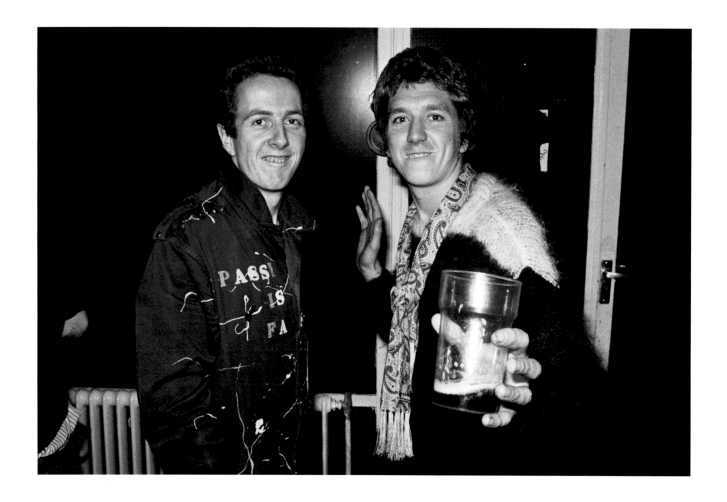

42.　　Paul Simonon, the Roxy, 1 January, 1977.

43.　　The Clash, the Roxy, 1 January, 1977. Director Julien Temple, in
　　　　black t-shirt, is filming the event for his student graduation film.

44.　　The first thing you learn... Fan with self-customized top waits for
　　　　the band, who are at the cinema watching *The Texas Chainsaw
　　　　Massacre*. Notre Dame de France, 15 November, 1976.

45.　　The women understand. Anna Capaldi goes to see the Clash at
　　　　the Lacey Lady and makes polite conversation with a new friend.
　　　　Future Generation X manager Stewart Joseph chaperones.

46.　　A riot of his own. Joe Strummer at "A Night of Treason,"
　　　　Royal College of Art, 5 November, 1976.

48.　　When students started throwing bottles, Joe asked them to
　　　　come onstage. One student complied. Then Sid Vicious
　　　　decided to "balance" the conversation. "A Night of Treason,"
　　　　Royal College of Art, 5 November, 1976.

50.　　Joe Strummer and Steve Jones, "A Night of Treason,"
　　　　Royal College of Art, 5 November, 1976.

51.　　Clash fan Adrian Thrills, "A Night of Treason," Royal College of Art,
　　　　5 November, 1976.

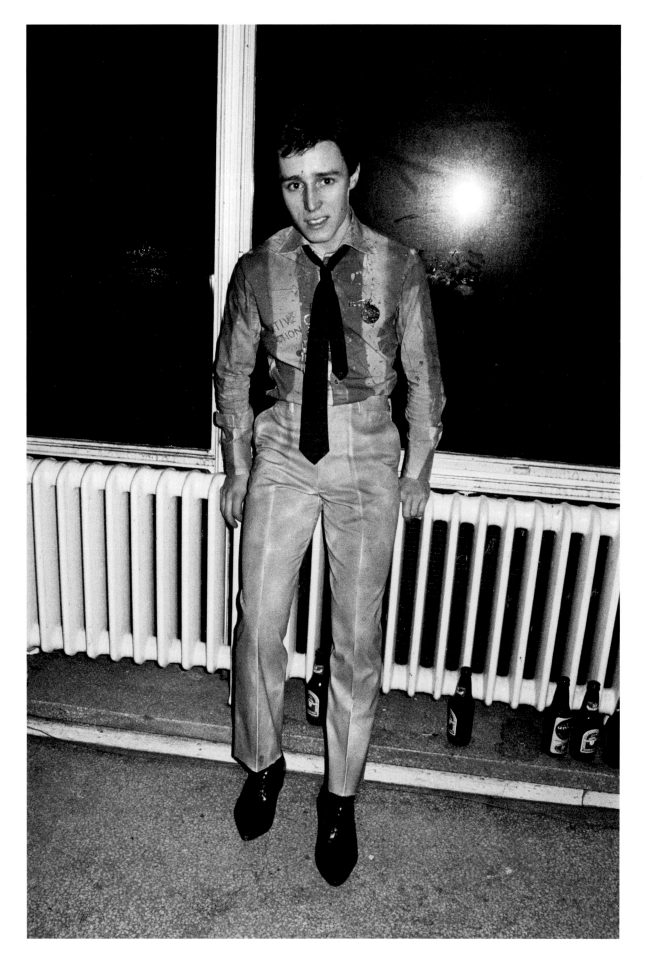

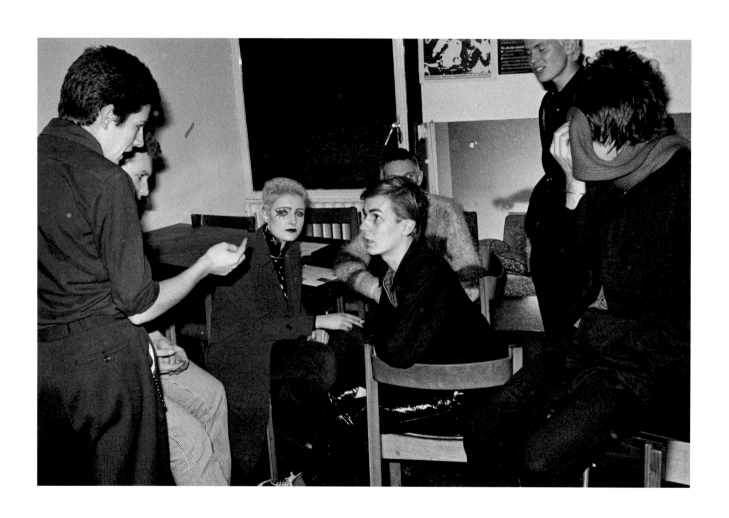

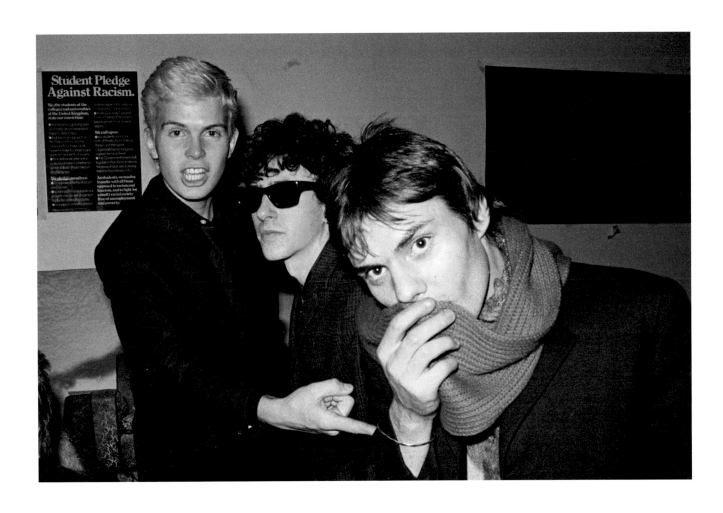

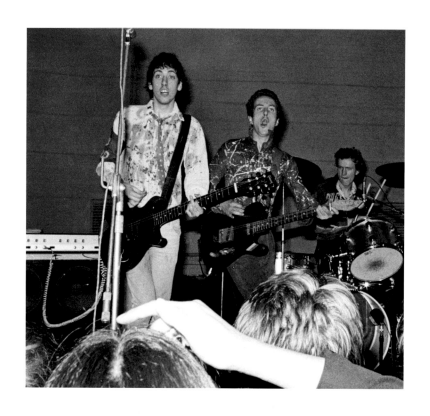

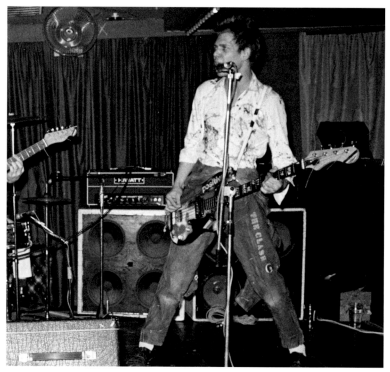

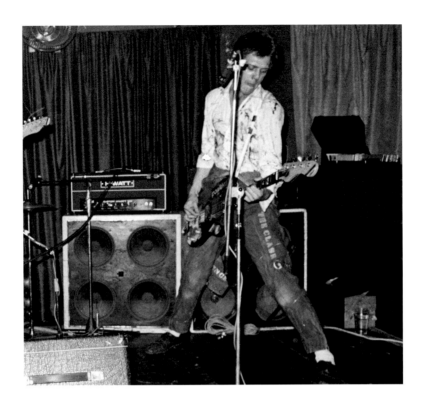

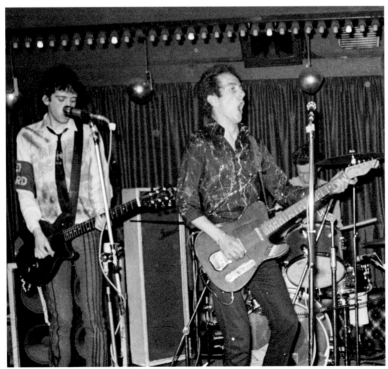

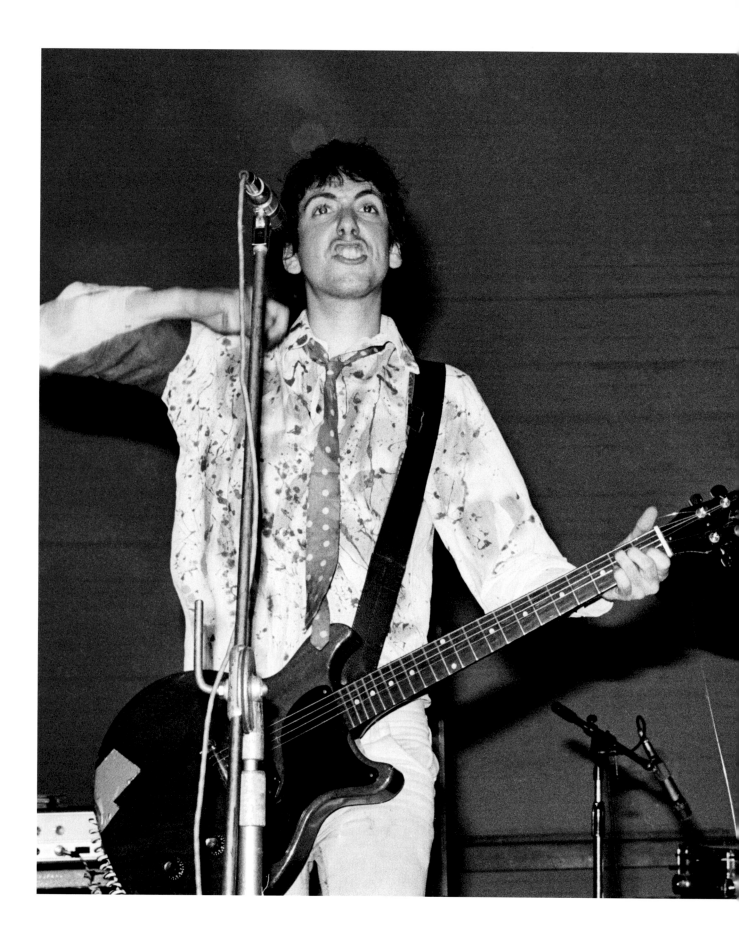

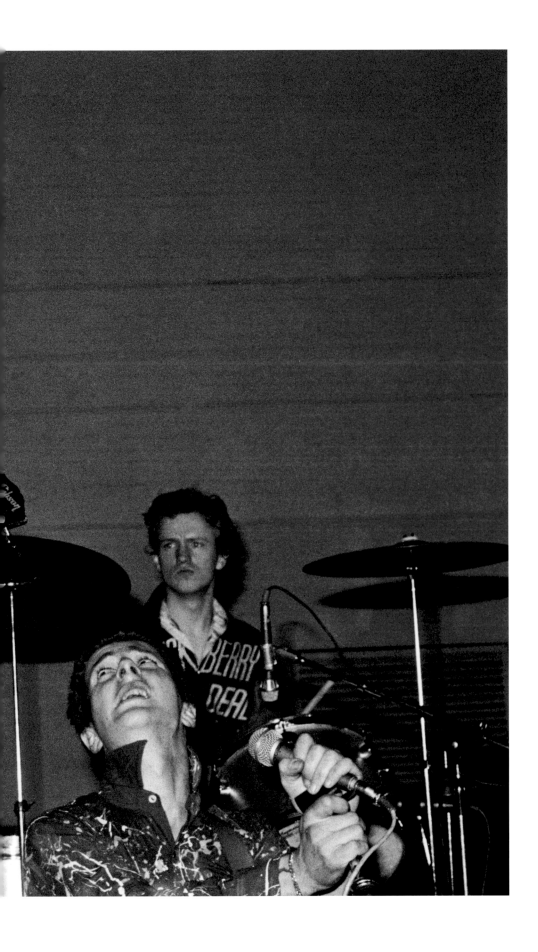

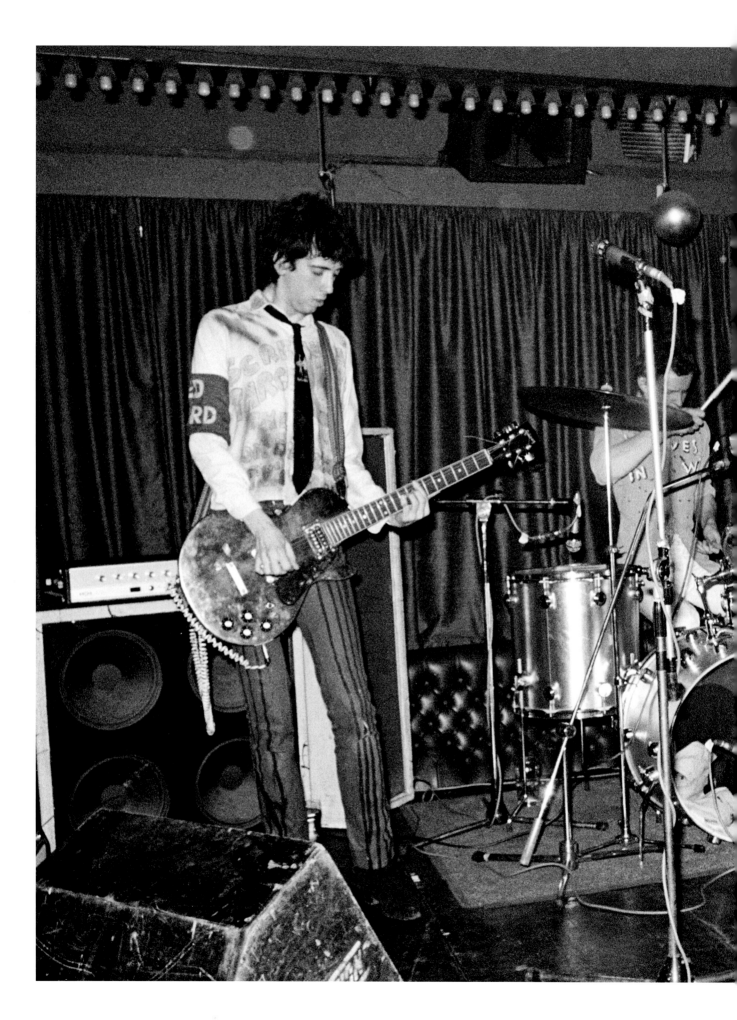

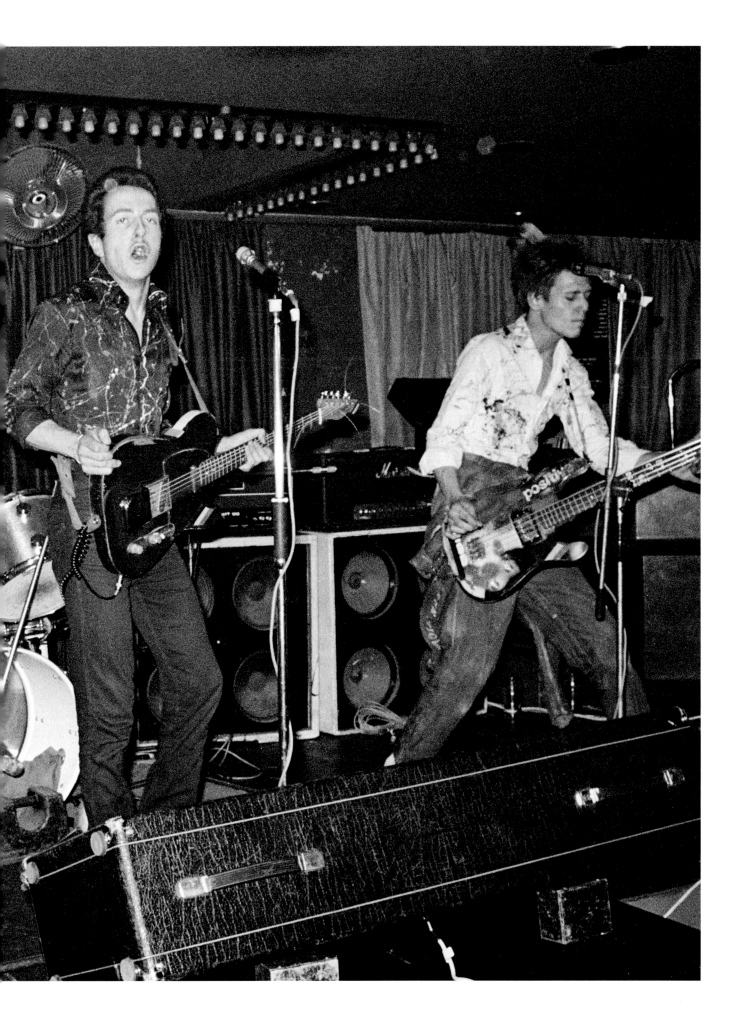

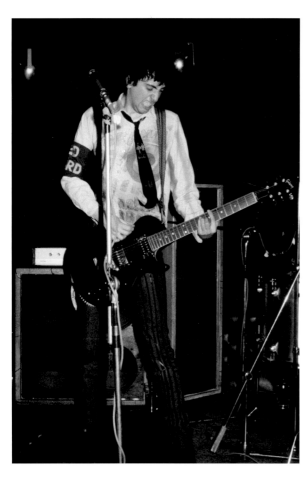

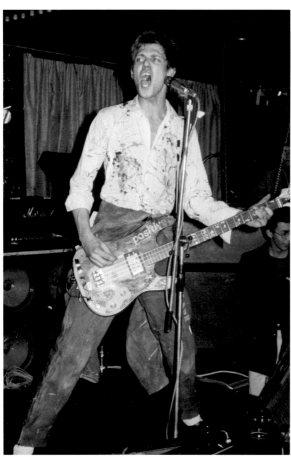

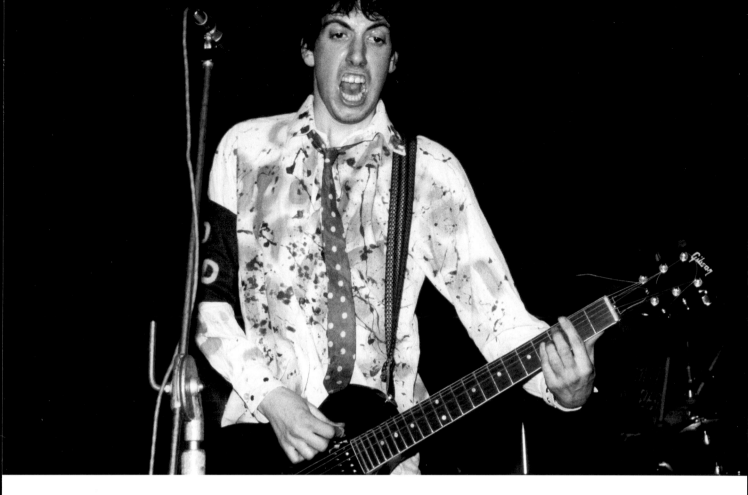

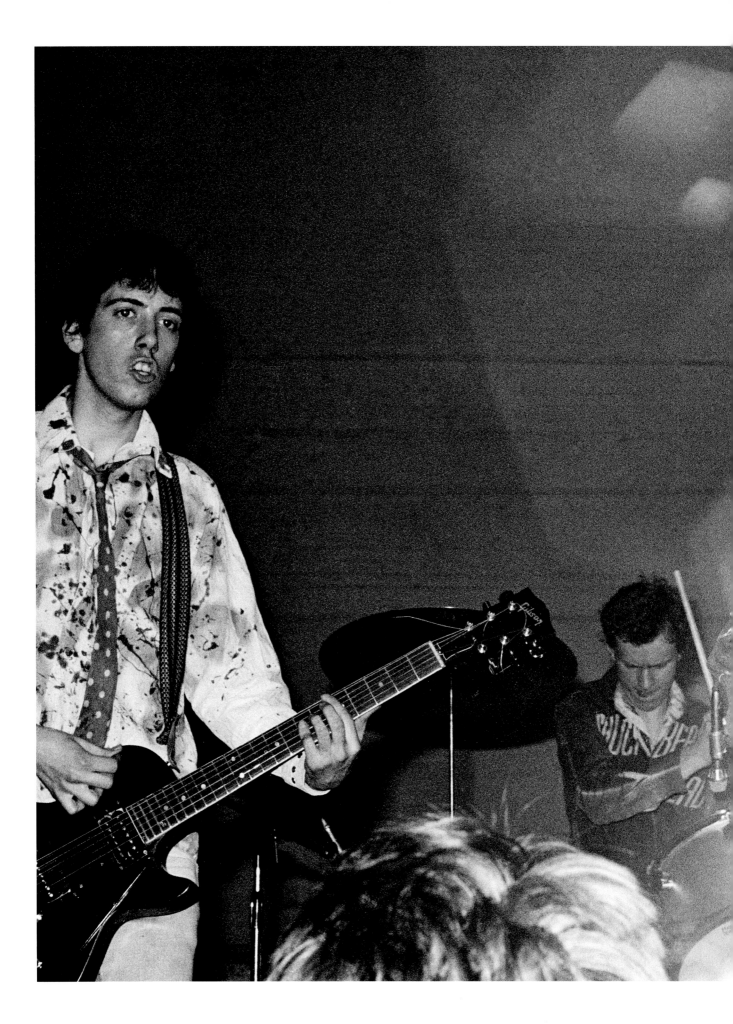

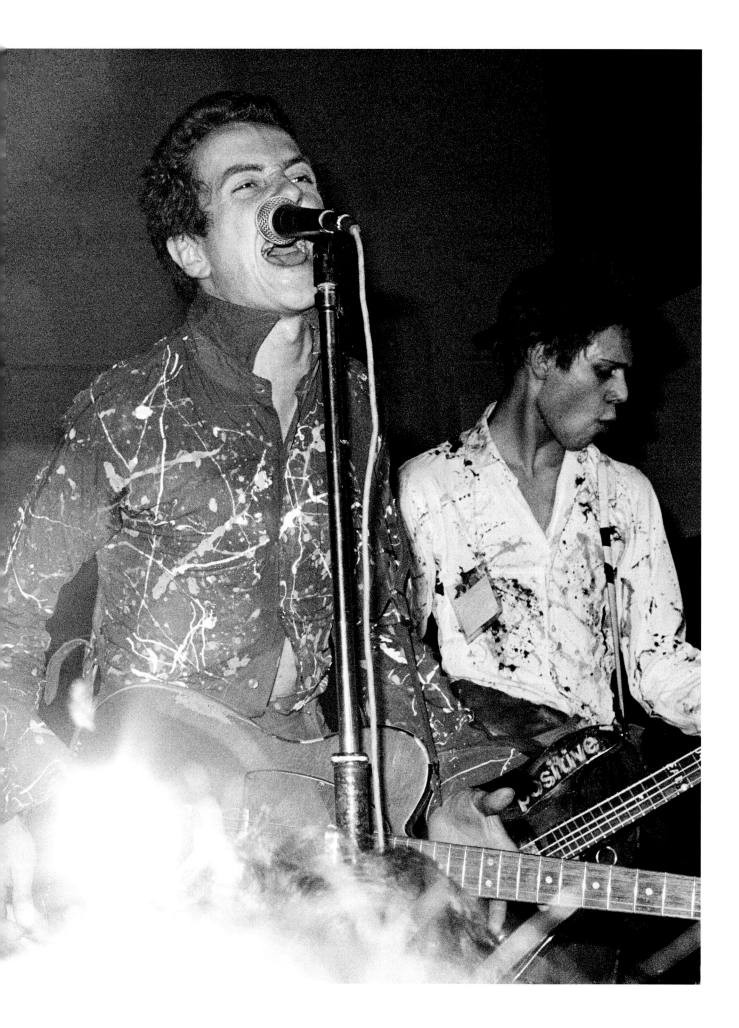

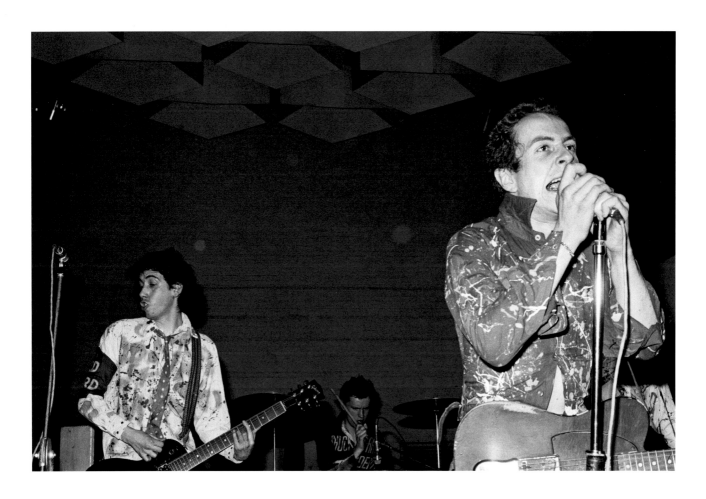

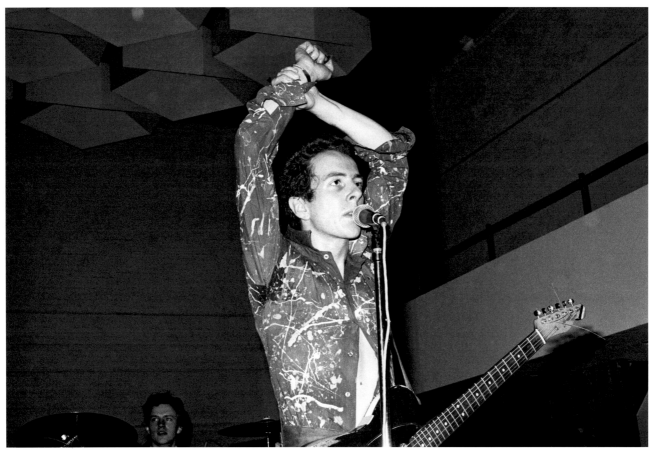

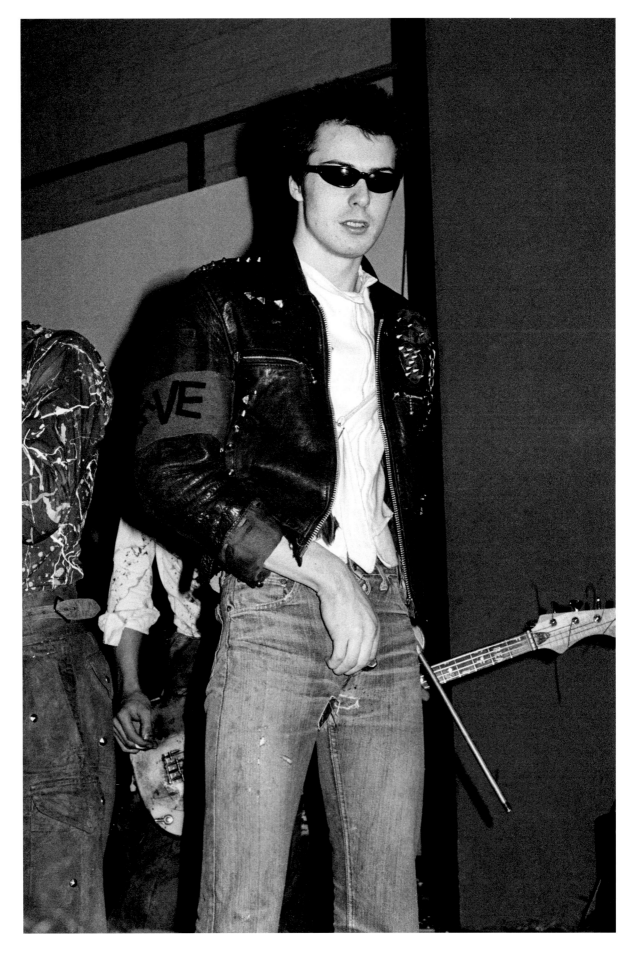

52. Plotting new bands… Siouxsie Sioux, Steve Severin, Simon Barker.

53. Don't look back. Billy Idol (guitar), Tony James (bass), Gene October (vocals) — Chelsea. They have played one gig. A week later Billy and Tony leave Gene, Billy moves from guitar to singer and they go looking for a guitarist. In December they relaunch themselves as Generation X.

54. **TOP:** Mick Jones, Joe Strummer, Terry Chimes, "A Night of Treason," Royal College of Art, 5 November, 1976. **BOTTOM:** The Clash, Lacey Lady, Ilford, 11 November, 1976.

56–7. Chuck Berry is Dead: Mick Jones, Terry Chimes and Joe Strummer lay down the beat of '76. "A Night of Treason," Royal College of Art, 5 November, 1976.

60–1. In living colour. For the first six months of their reign the Clash stood out by splattering their clothes with paint and stenciling militant reggae slogans from their lyrics.

64. Joe responds to the flying bottles by throwing his arms above his head and sneering, "Under heavy manners." "A Night of Treason," Royal College of Art, 5 November, 1976.

65. Sid Vicious onstage telling off the students. "A Night of Treason," Royal College of Art, 5 November, 1976.

67. Subway Sect. Singer Vic Godard enjoys his band from a relaxed position. "A Night of Treason," Royal College of Art, 5 November, 1976.

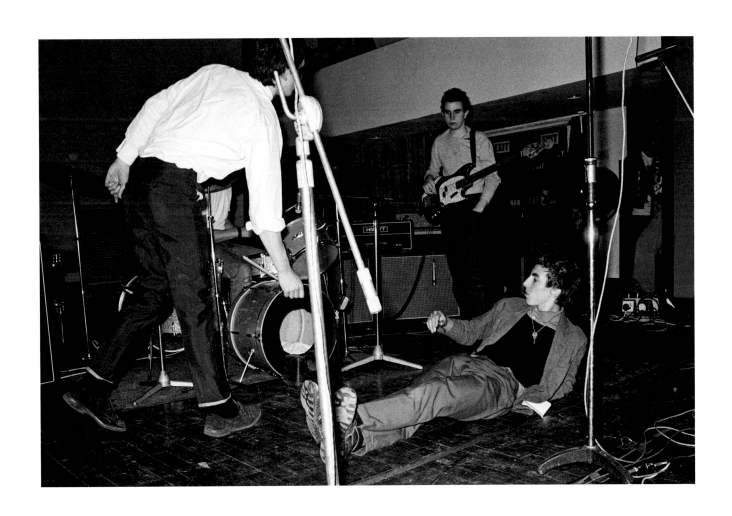

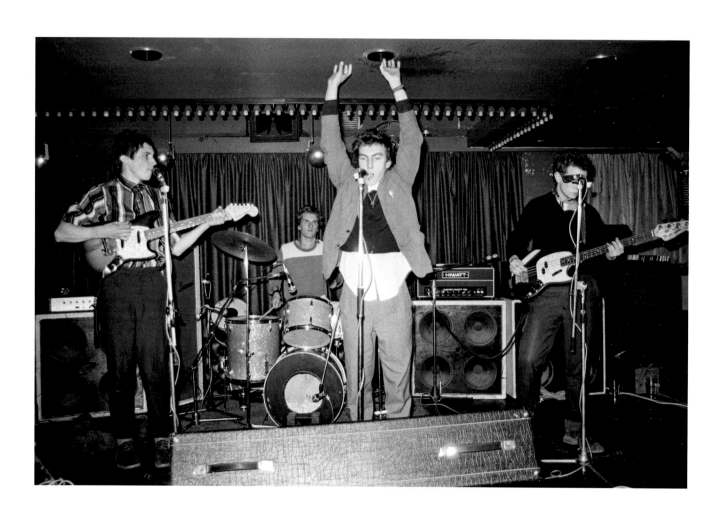

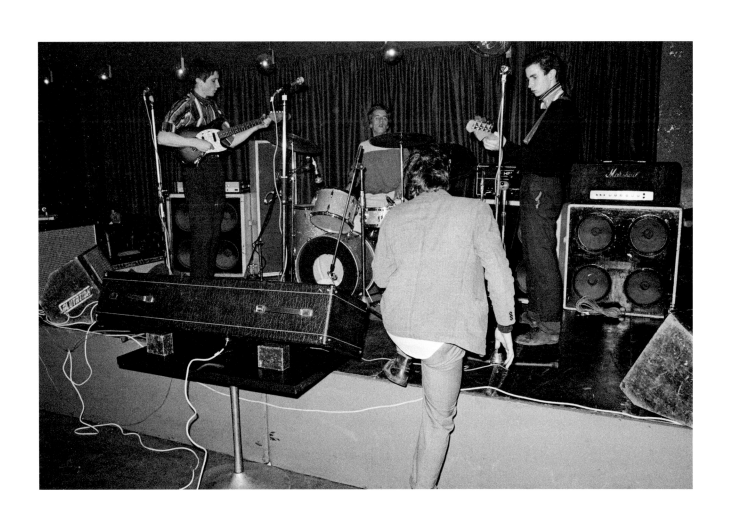

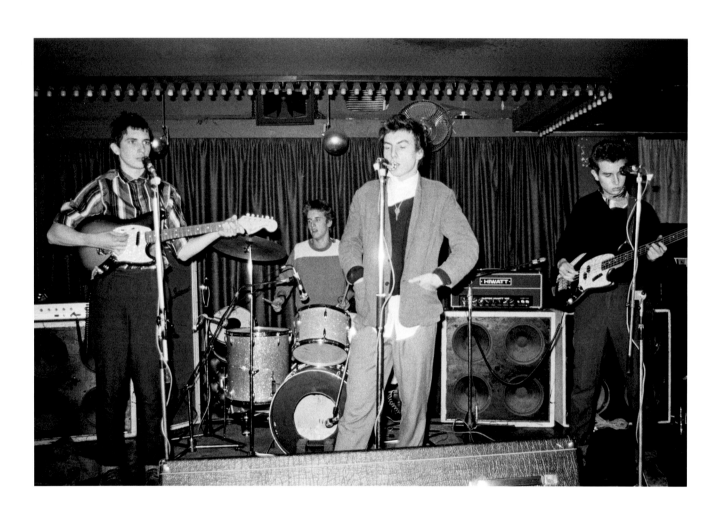

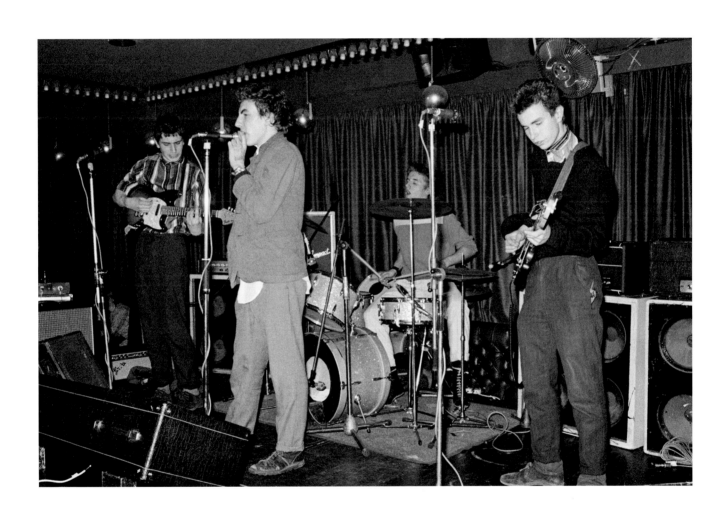

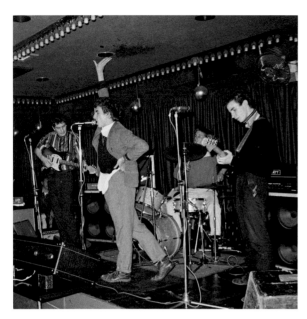

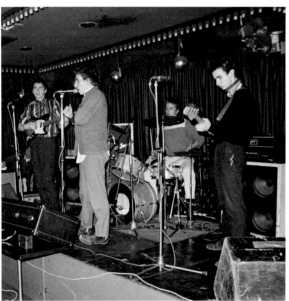

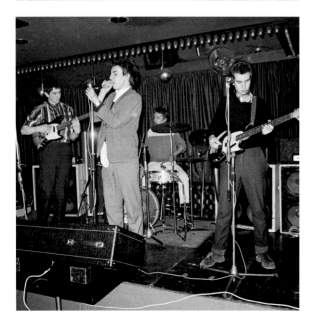

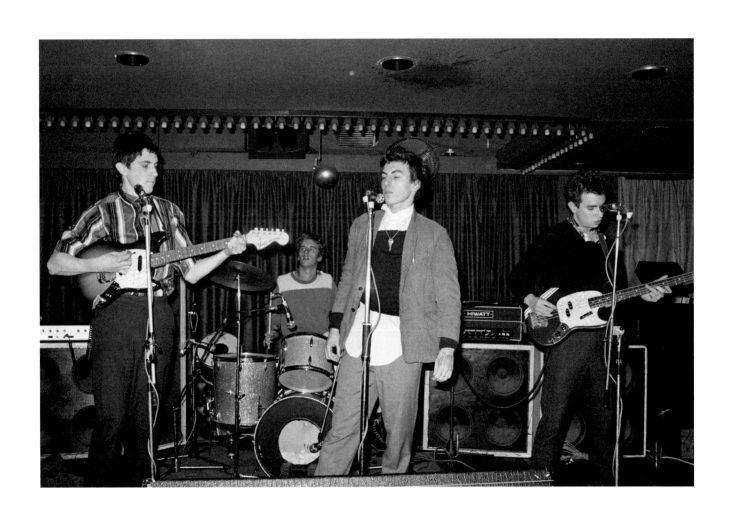

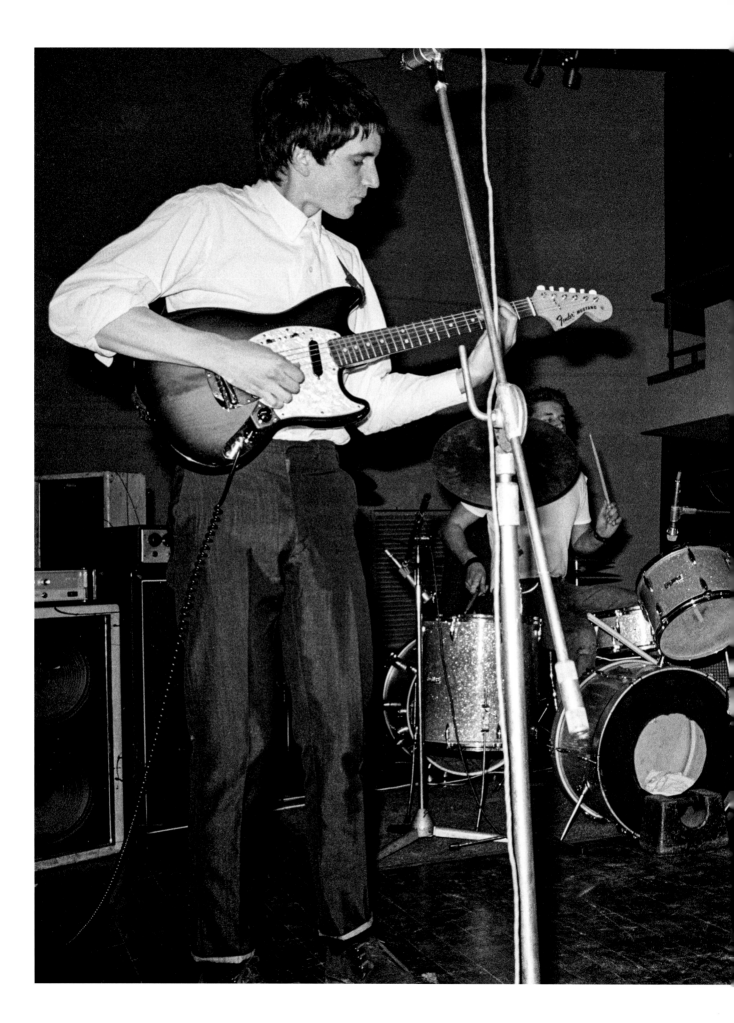

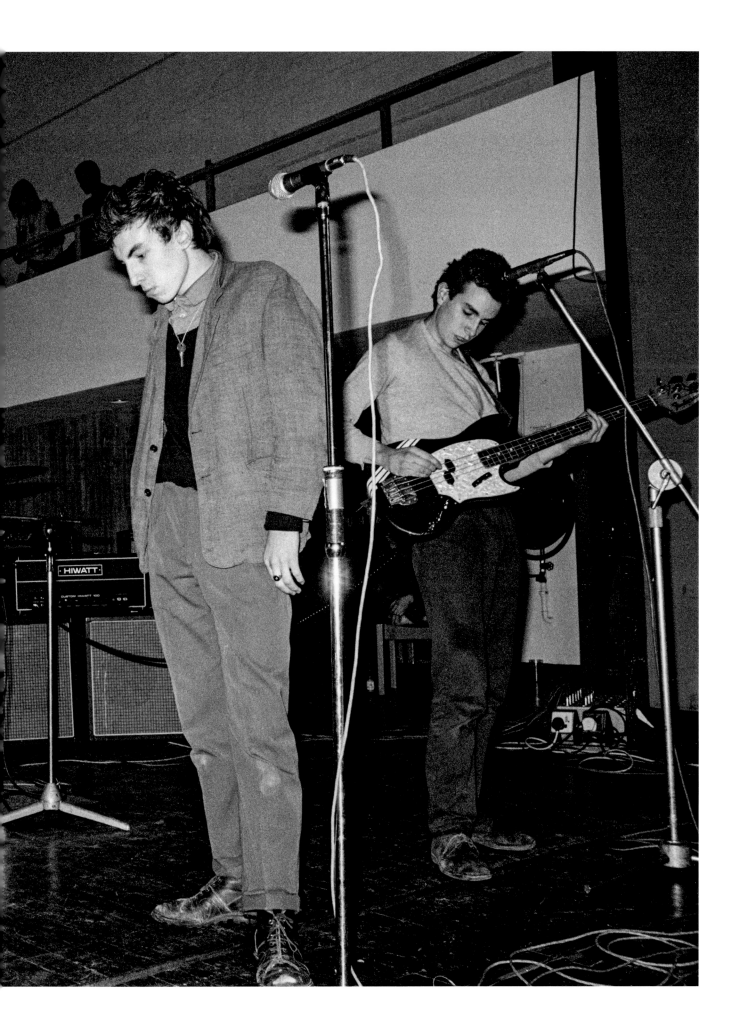

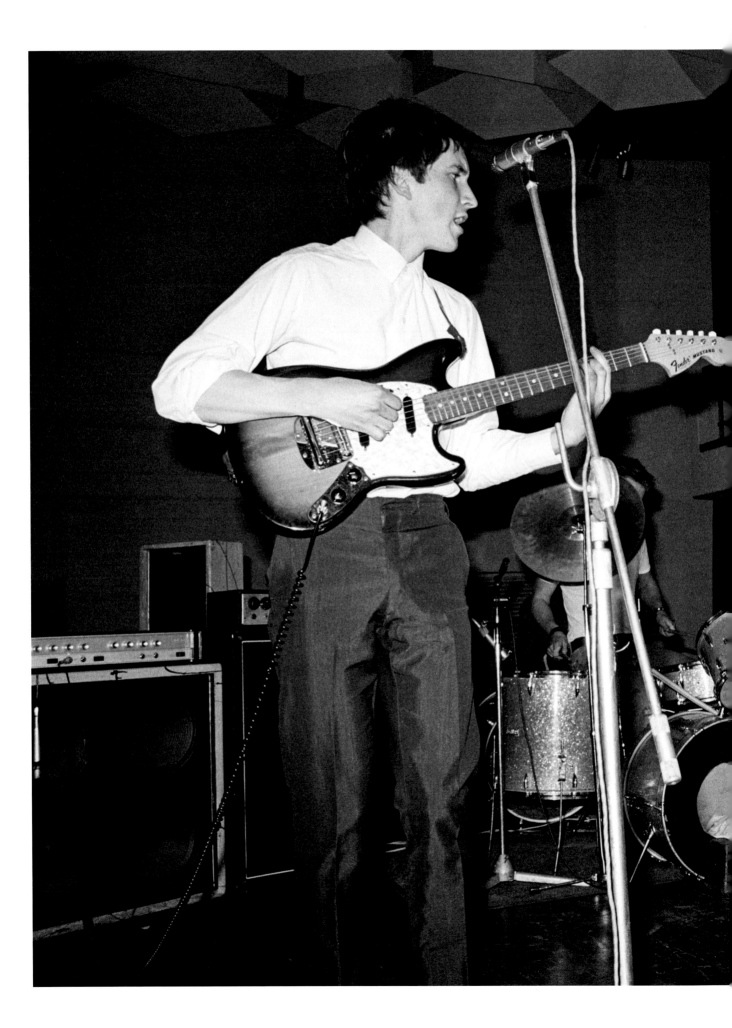

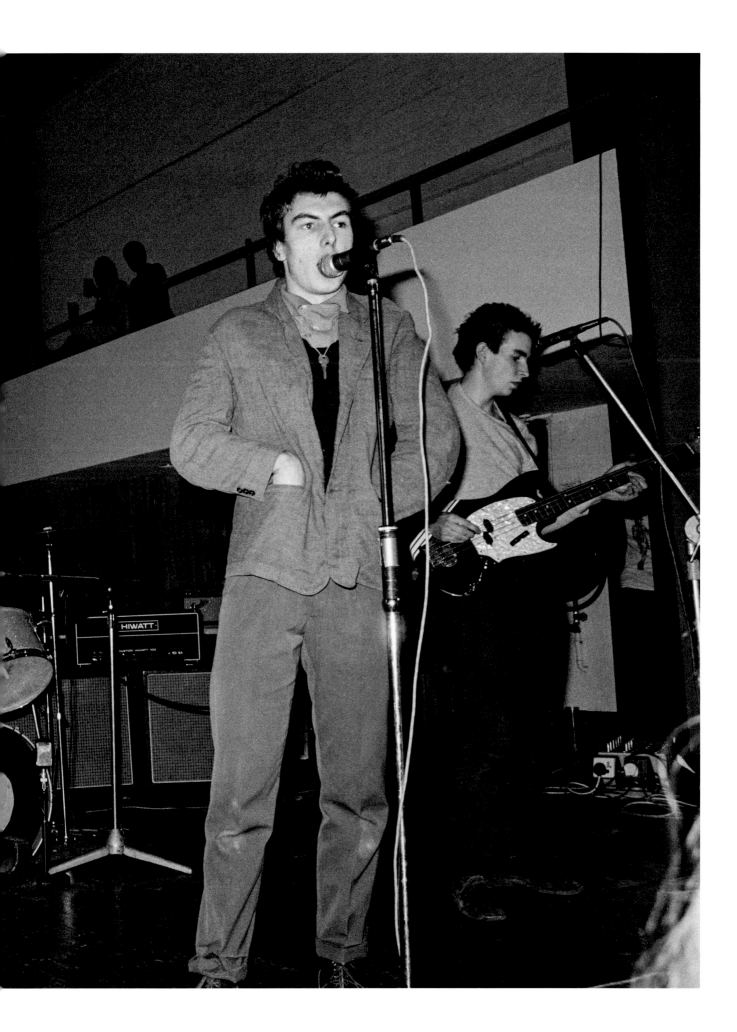

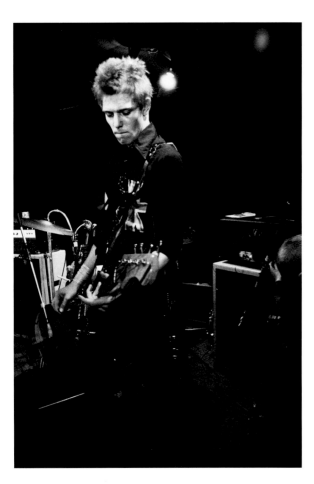

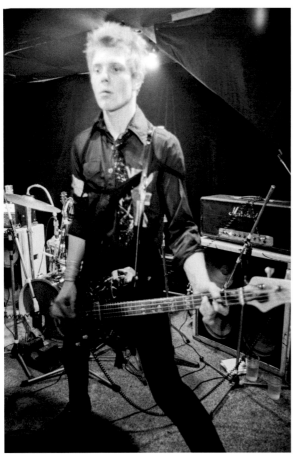

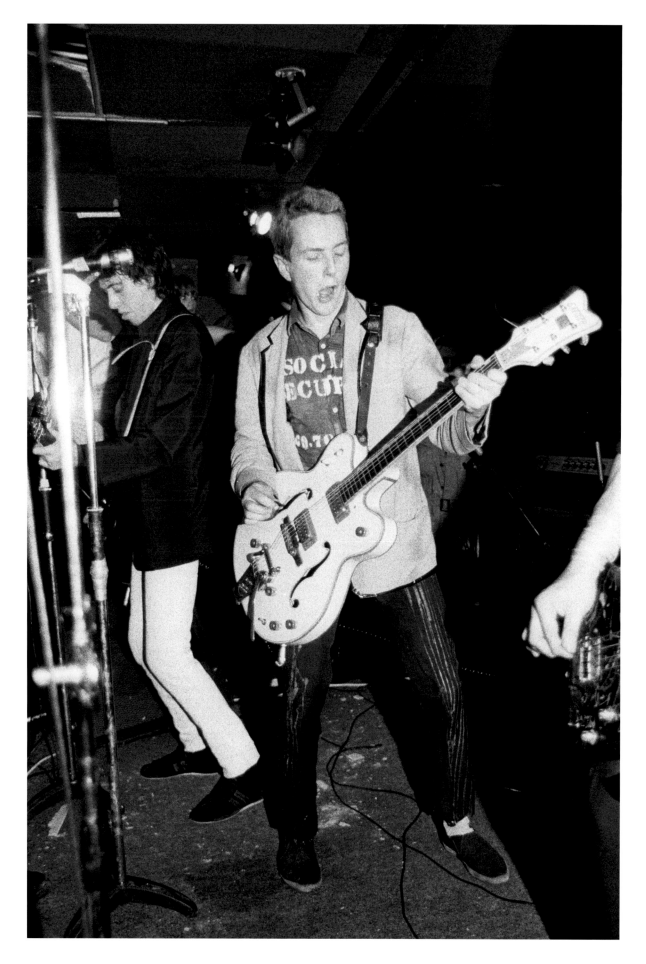

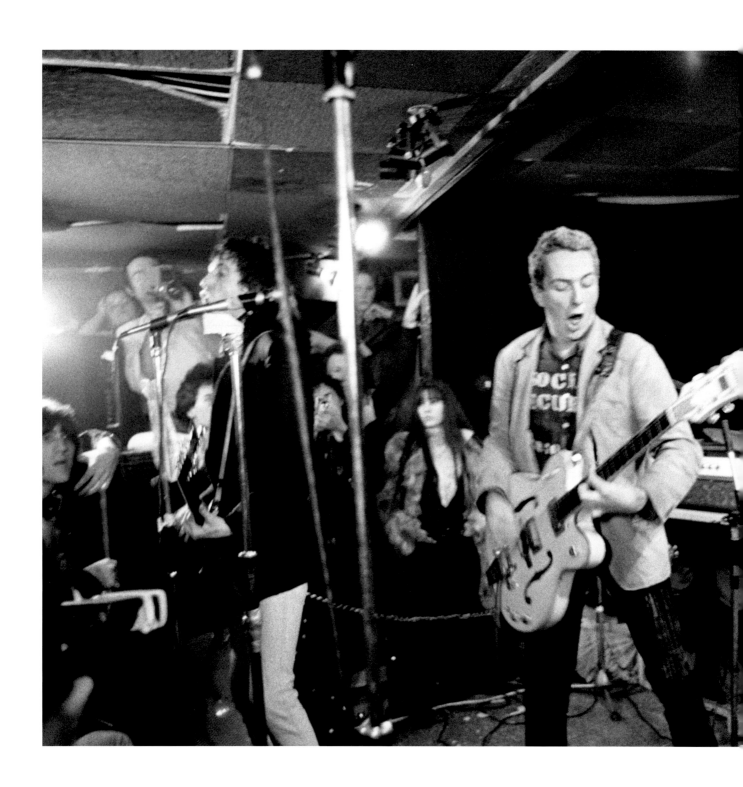

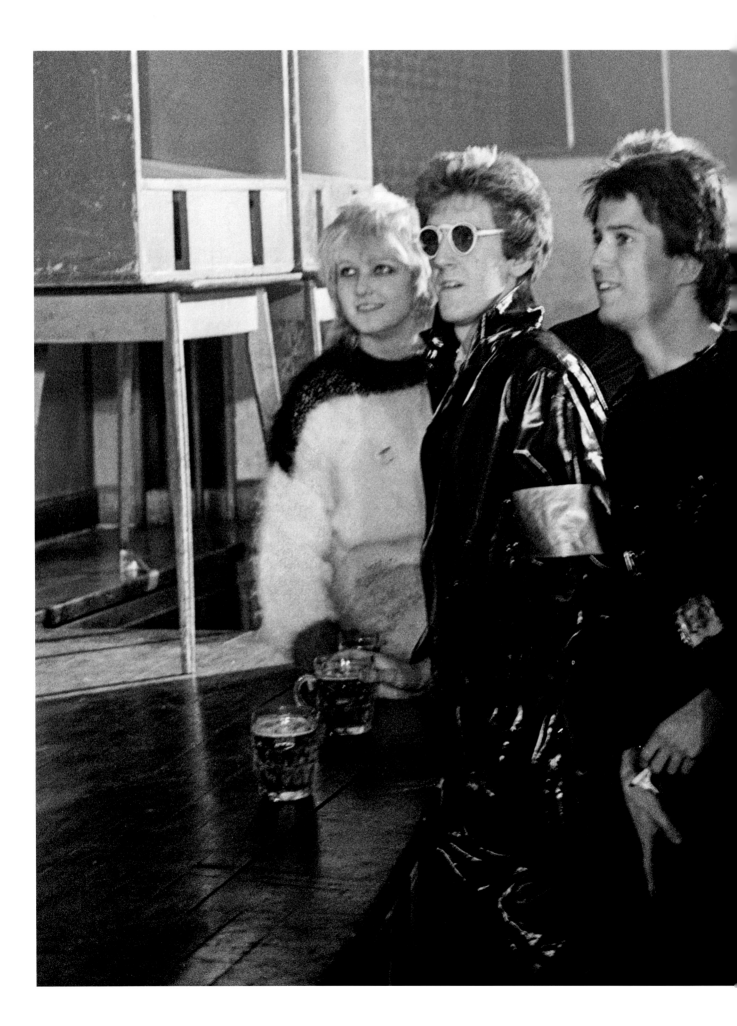

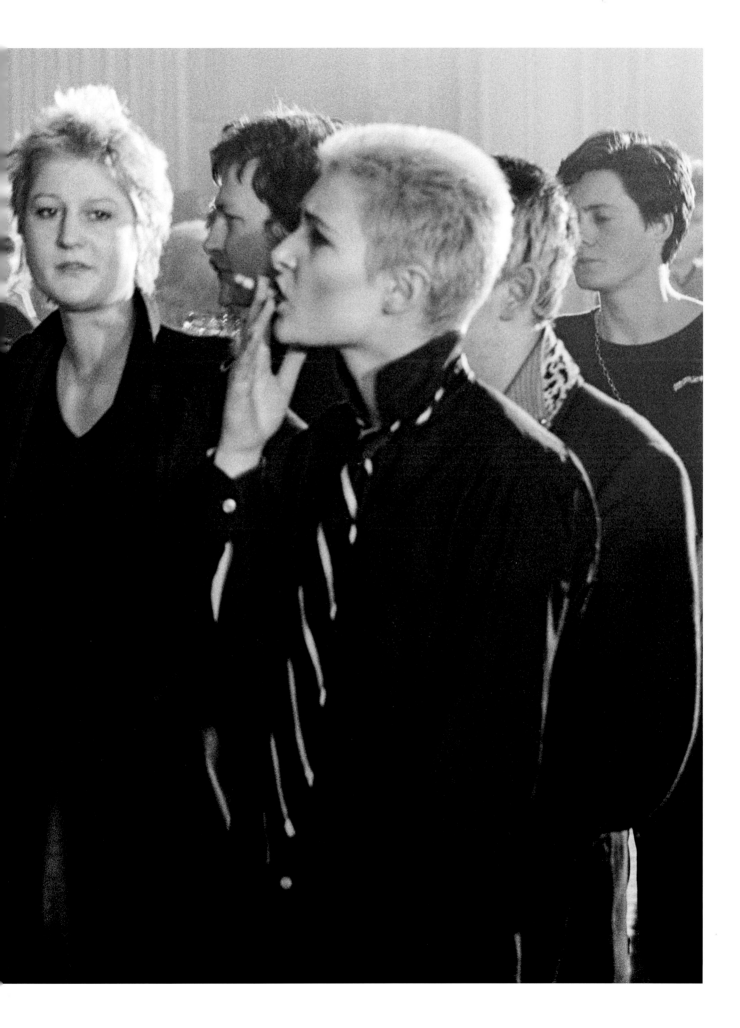

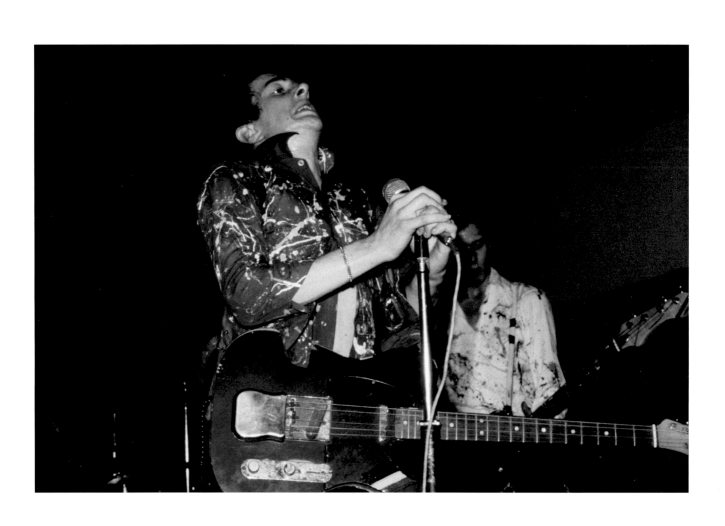

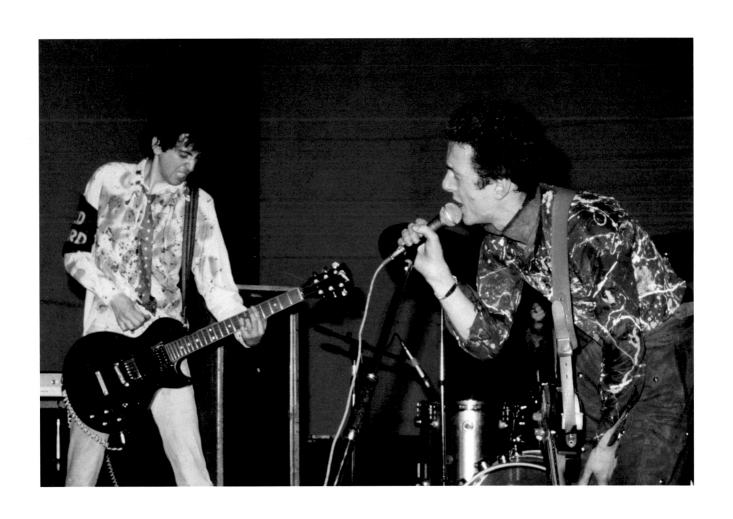

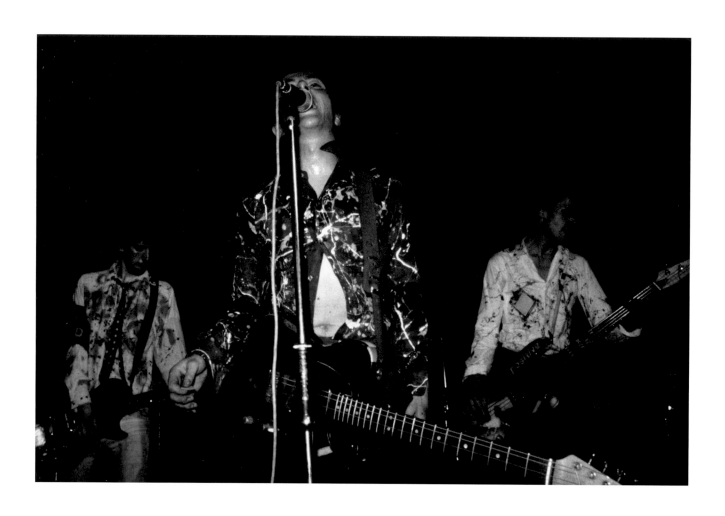

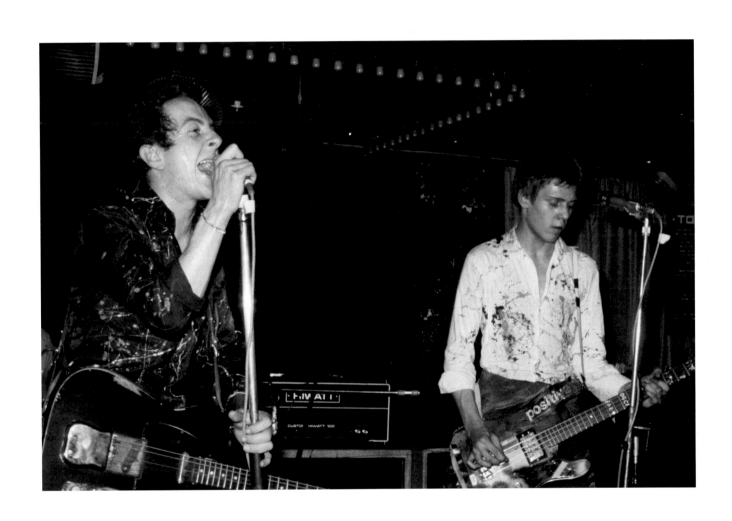

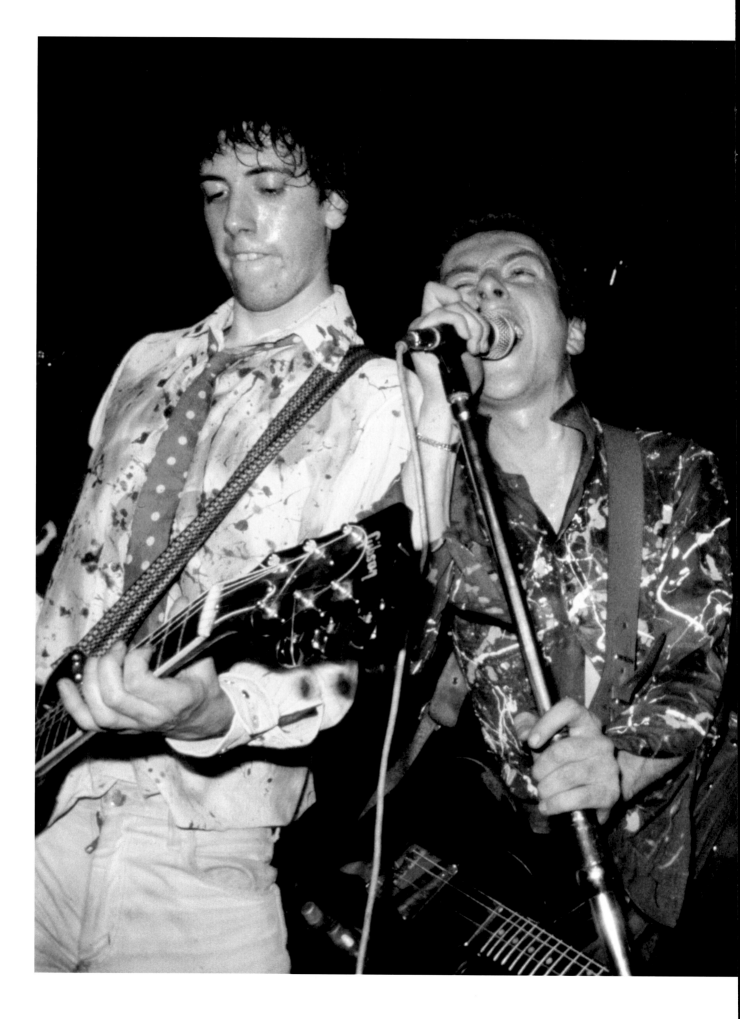

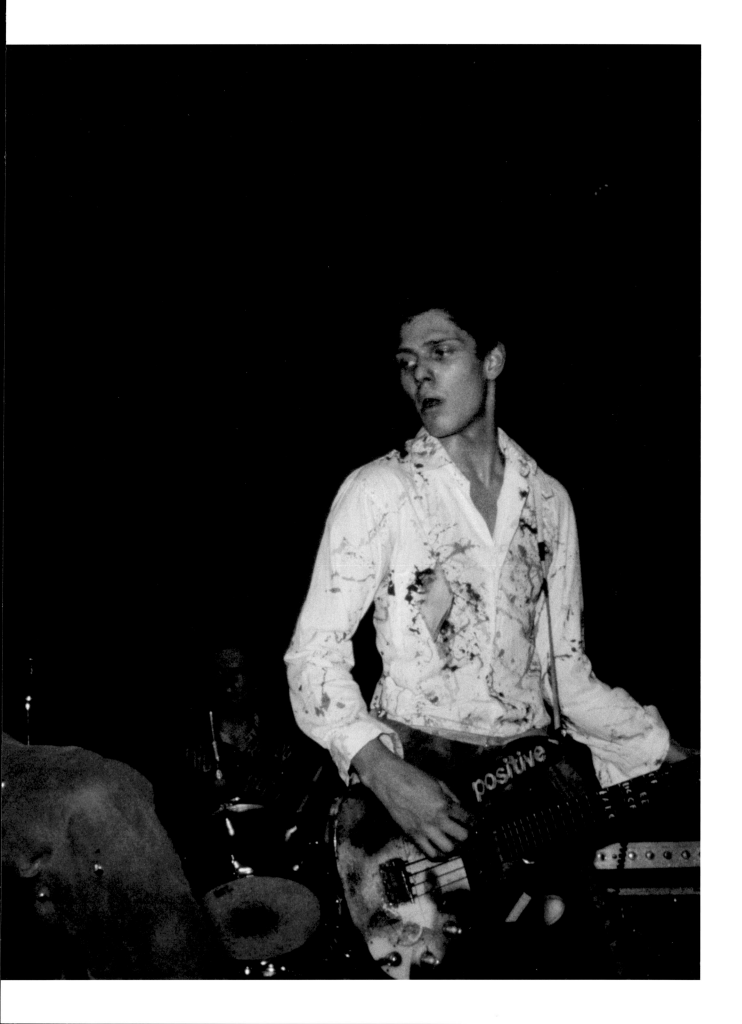

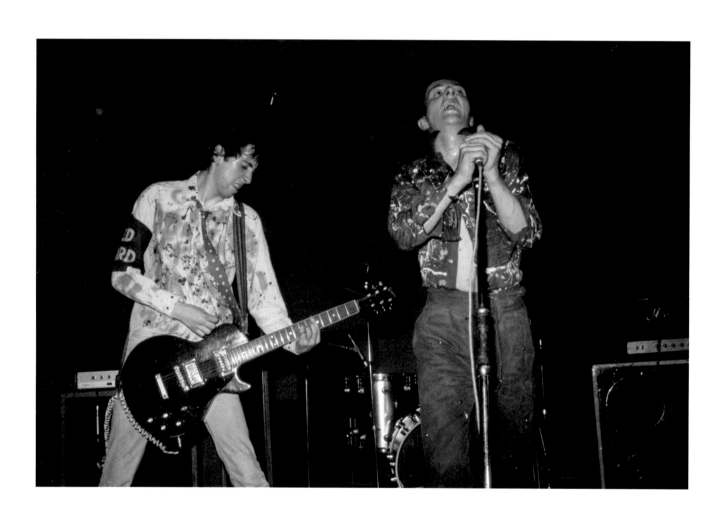

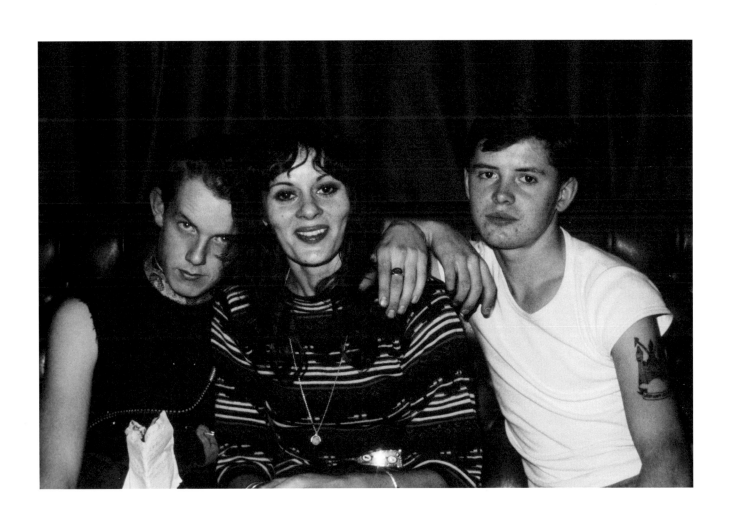

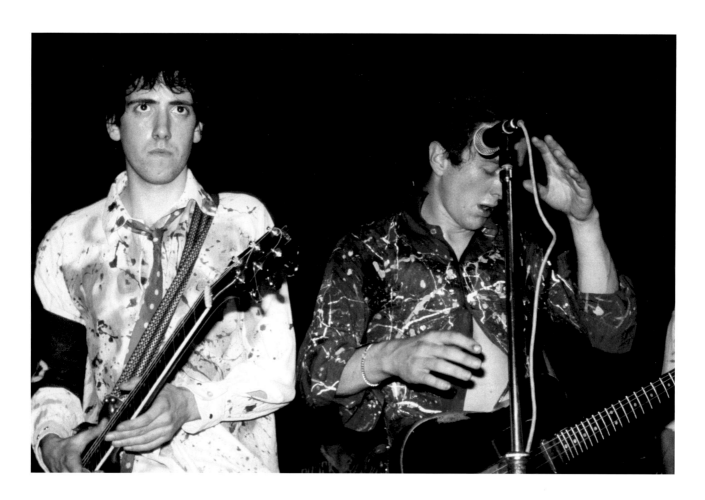

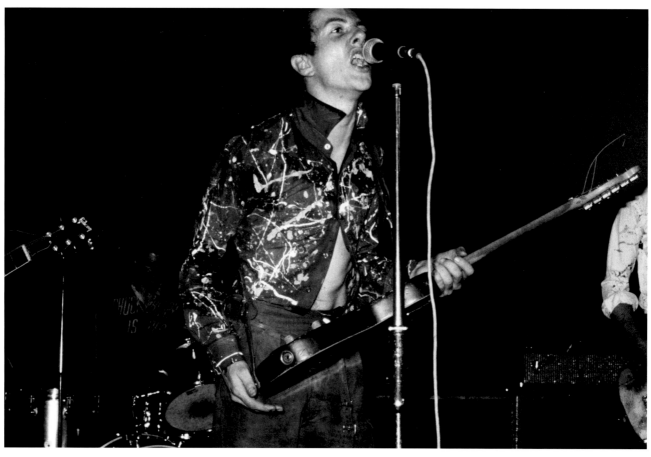

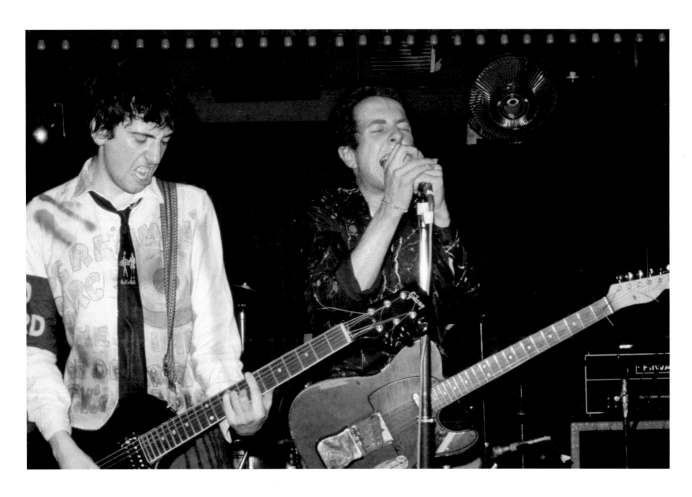

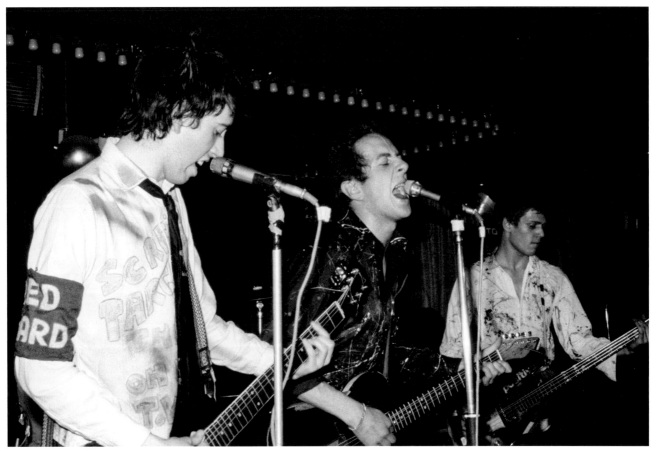

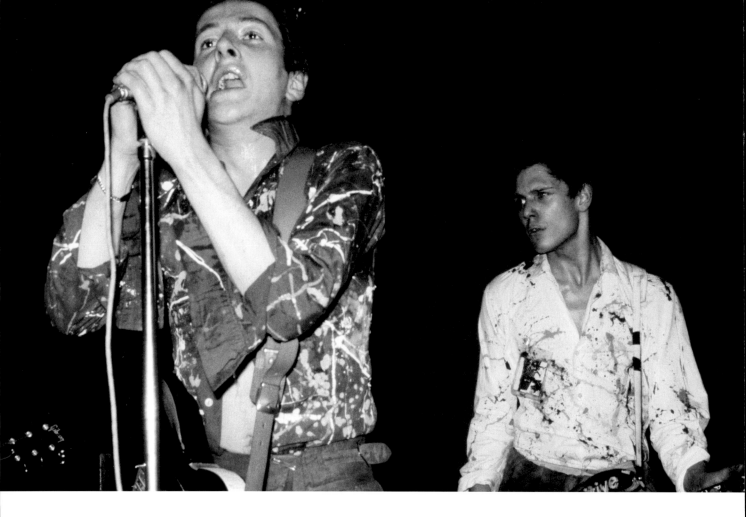

69. Subway Sect. Singer Vic Godard decides to watch the guitar
 solo from the audience. Lacey Lady, Ilford, 11 November, 1976.

78. The Clash, the Roxy, 1 January, 1977.

82–3. Friends and countrymen at the Sex Pistols, Notre Dame de France,
 15 November, 1976. Viv Albertine far left, Siouxsie Sioux smoking
 cigarette, Steve Severin behind her, Kenny Morris behind him.
 In the middle is Sarah Hall, one of the two ladies who came with
 John to the first interview in April.

84. A band to change your life. The Clash at the Royal College of Art,
 5 November, 1976.

91. Anna Capaldi, ex-wife of Traffic drummer Jim Capaldi, discusses
 the fine points of Punk with Clash fans at the Lacey Lady.

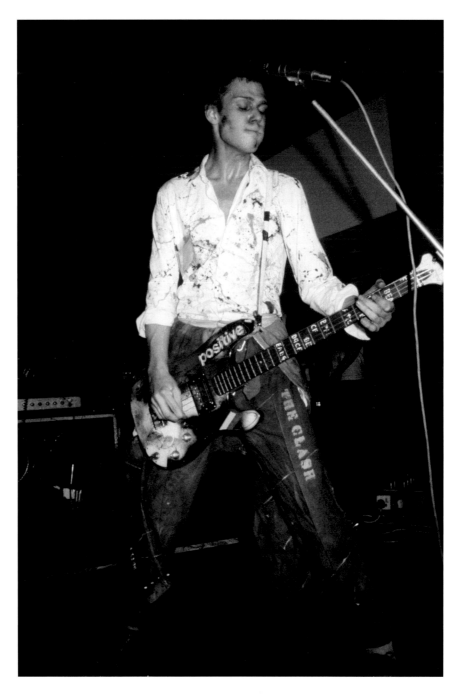

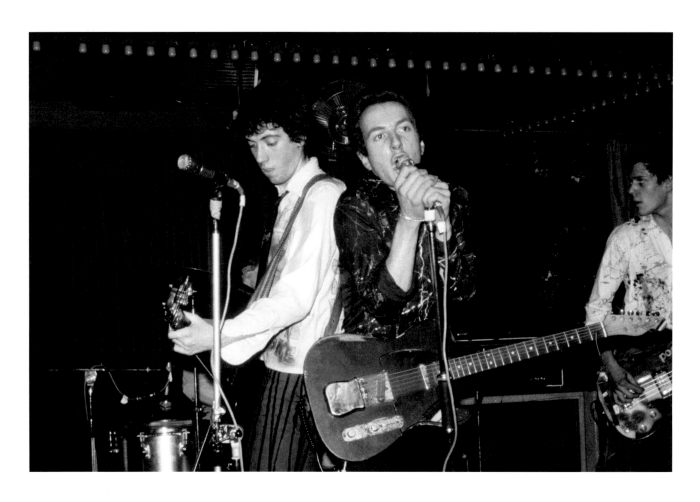

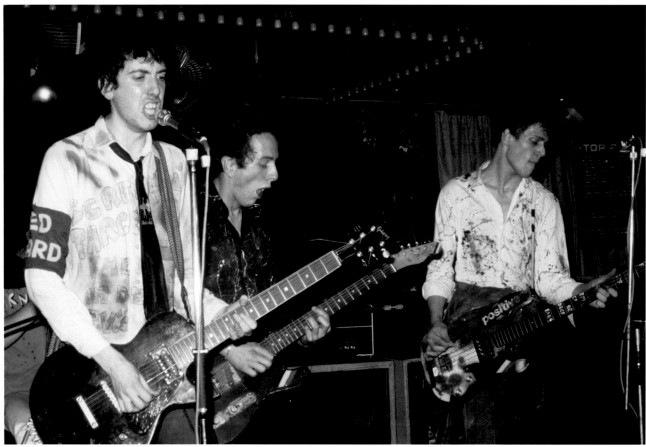

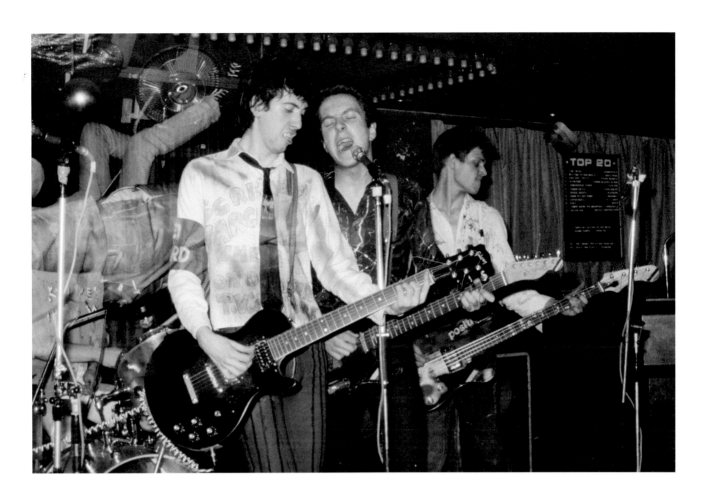

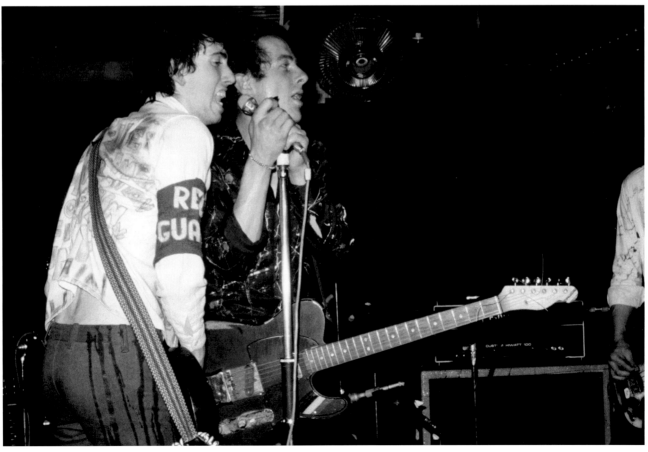

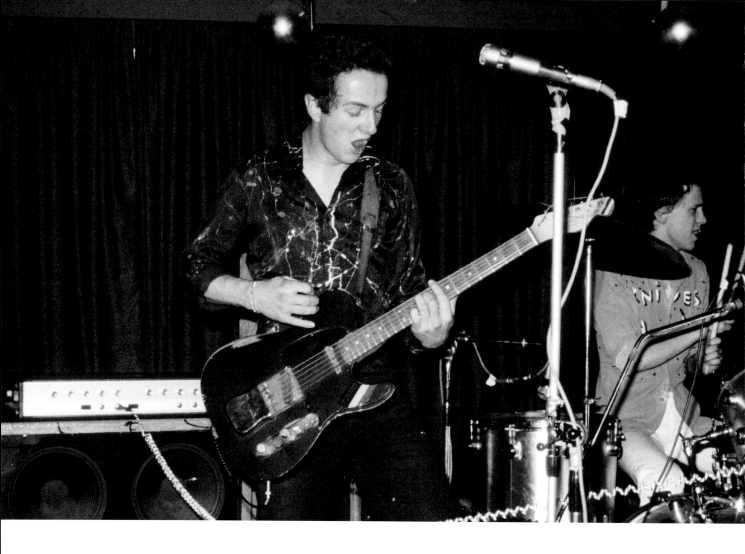

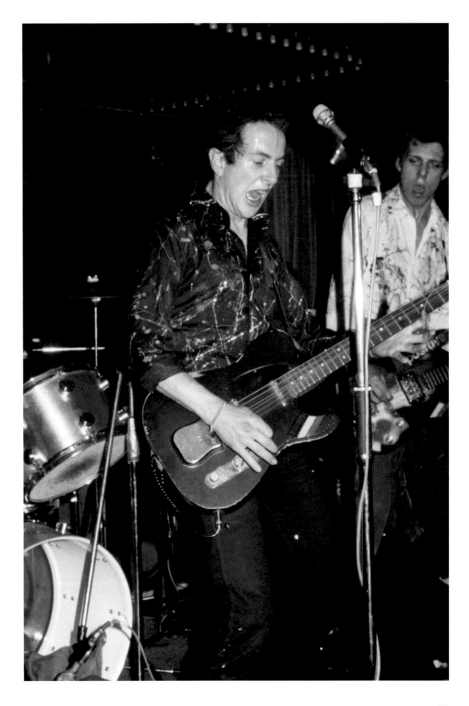

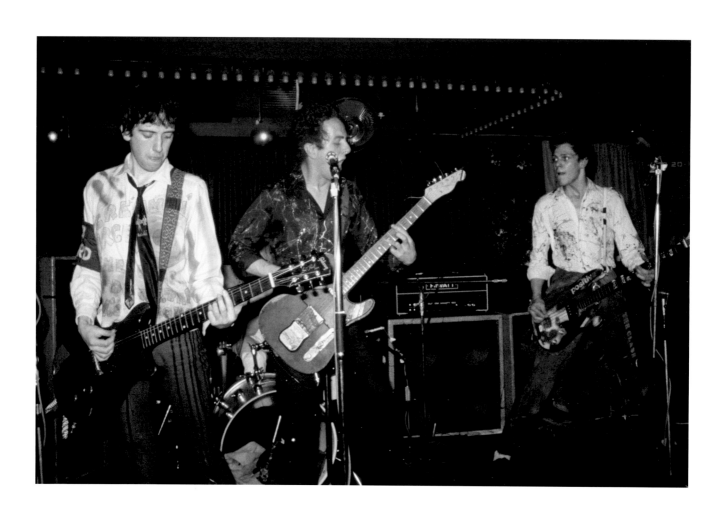

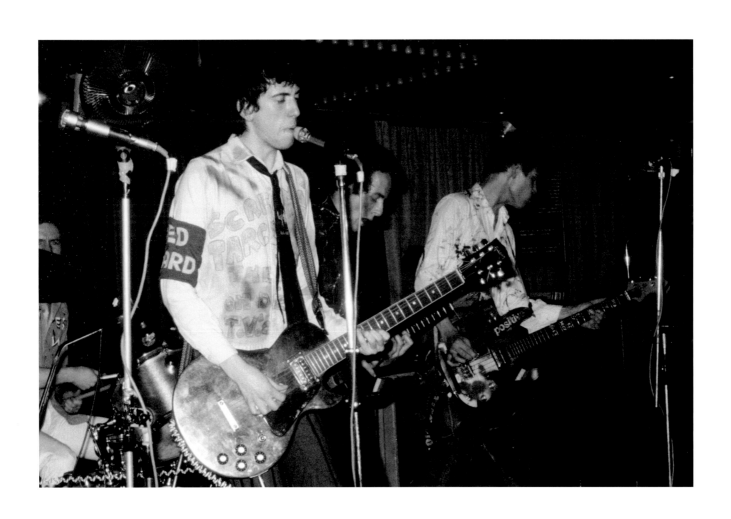

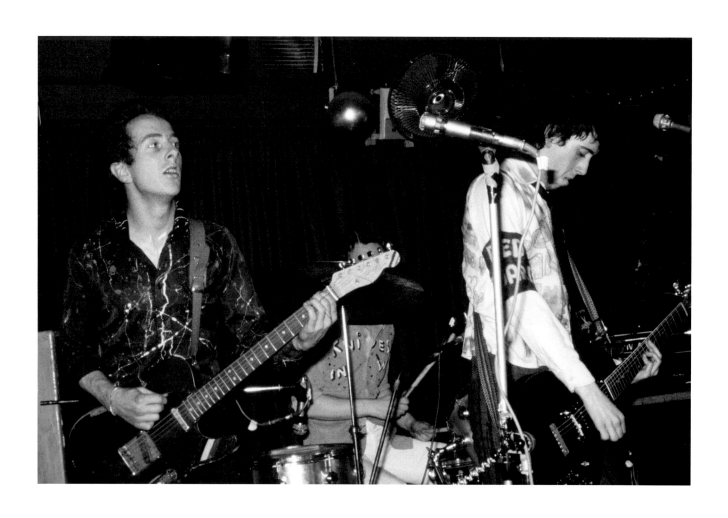

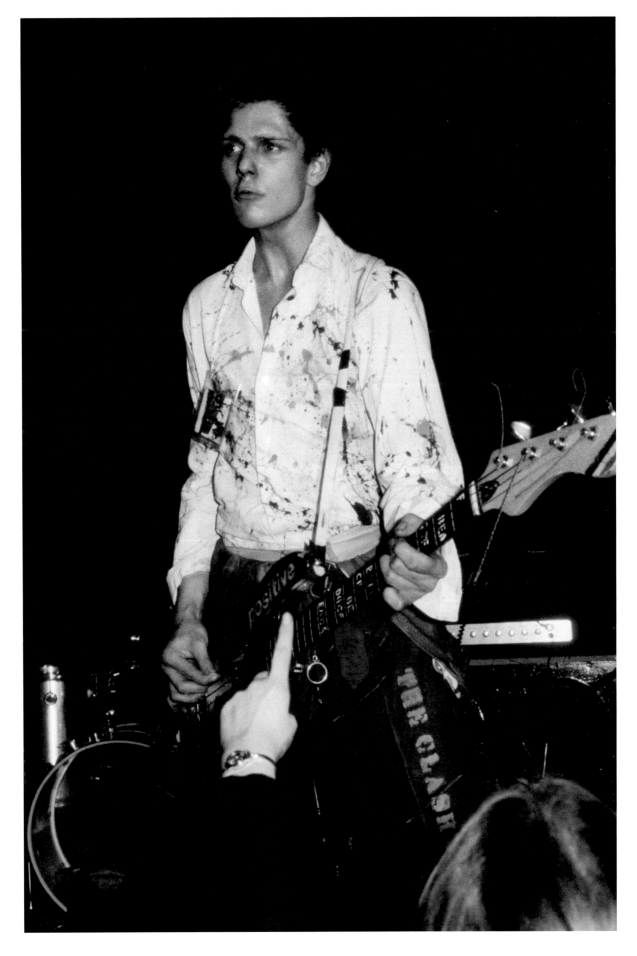

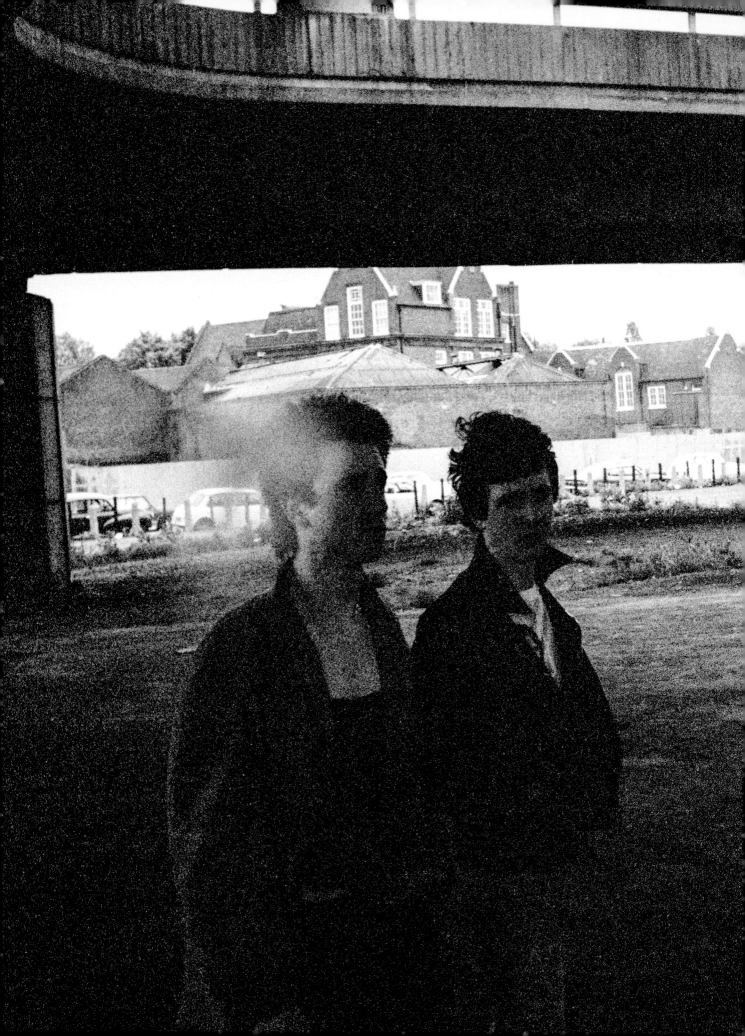

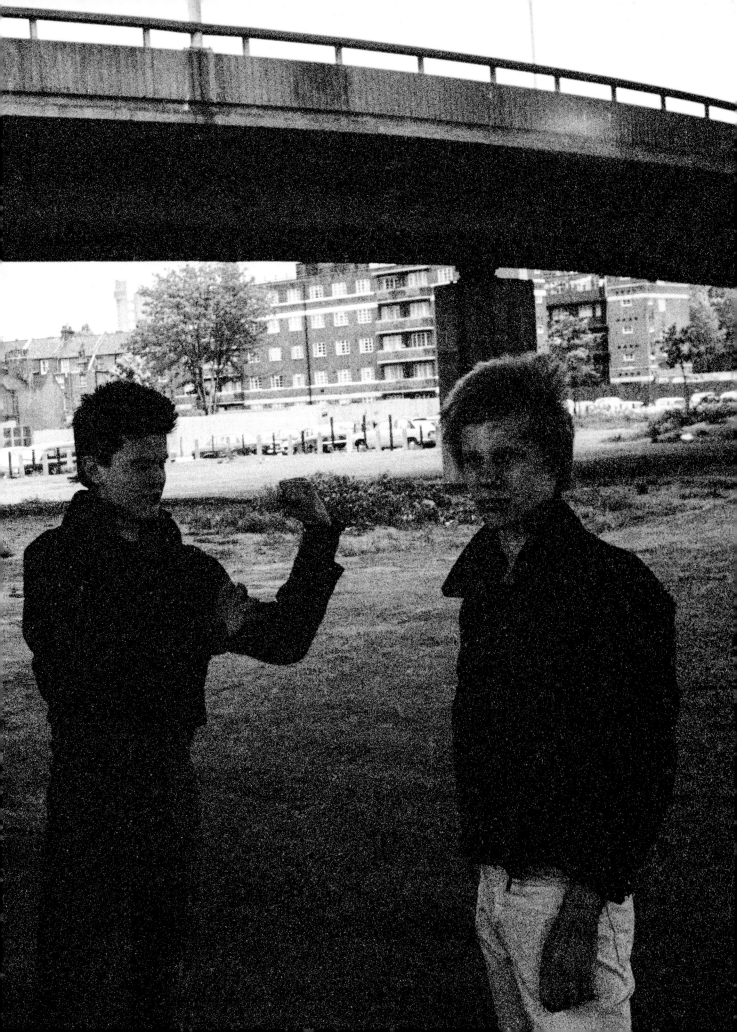

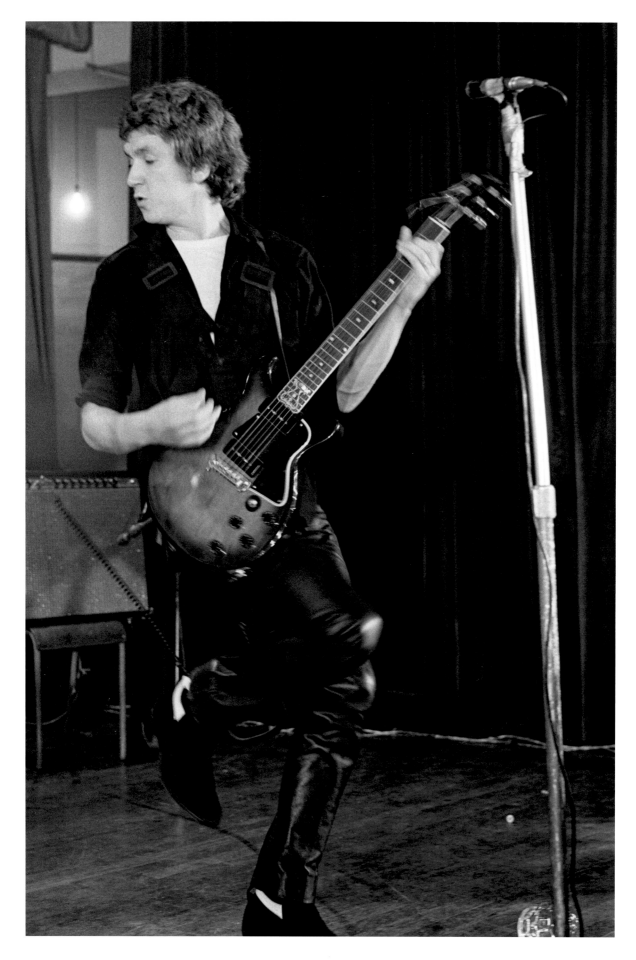

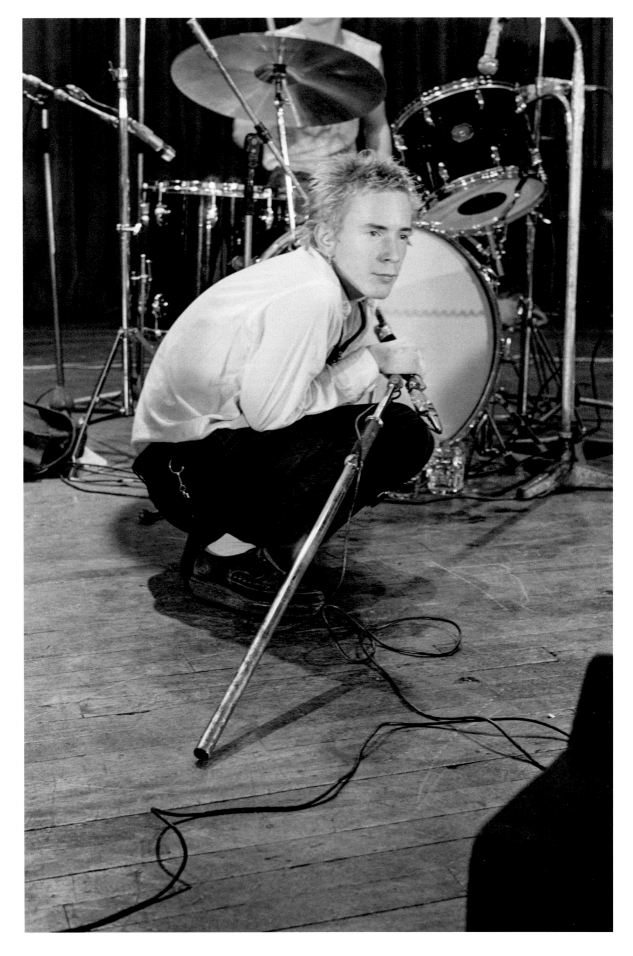

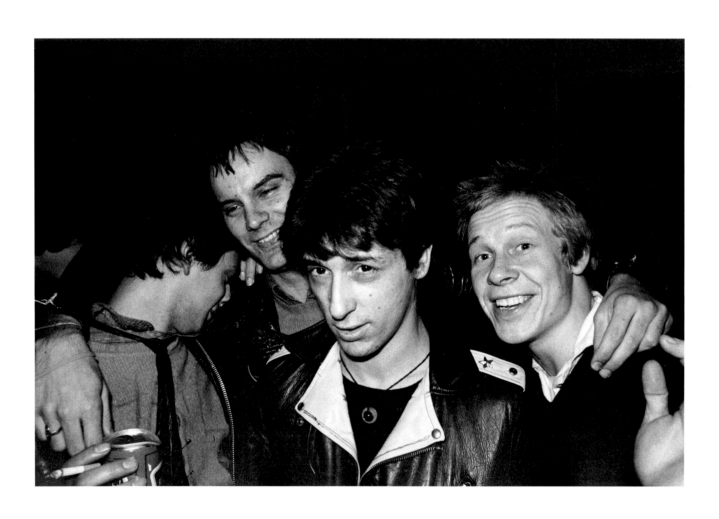

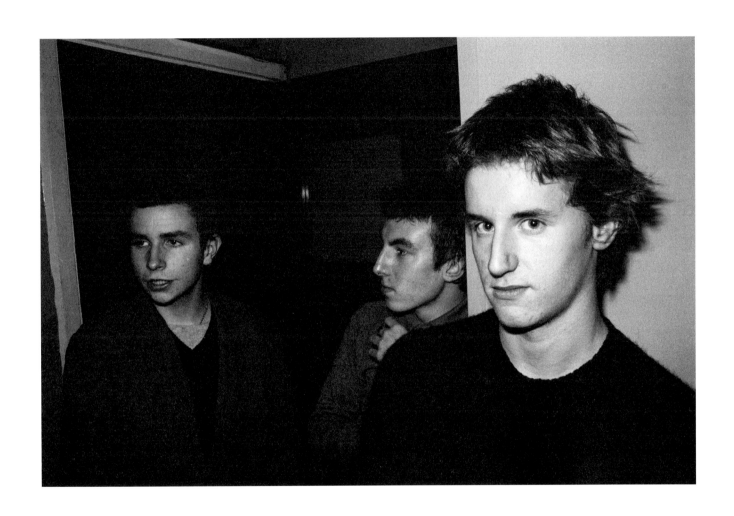

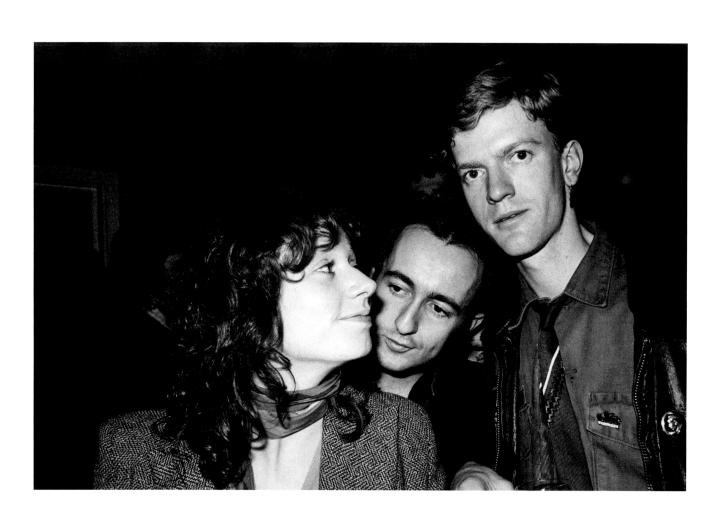

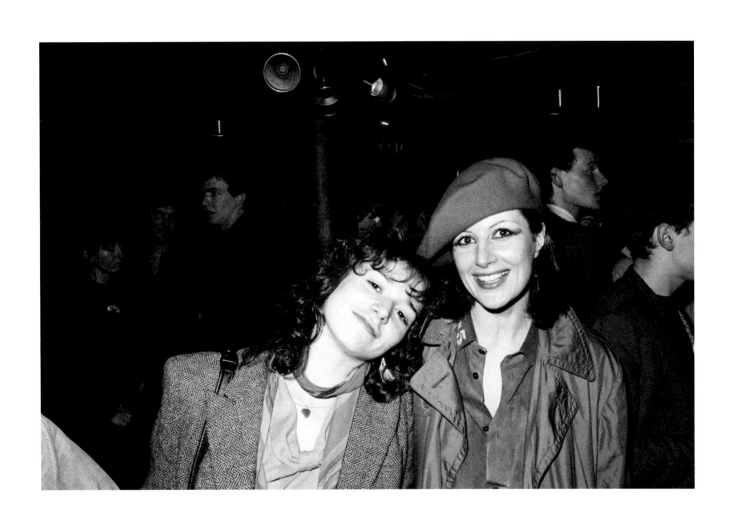

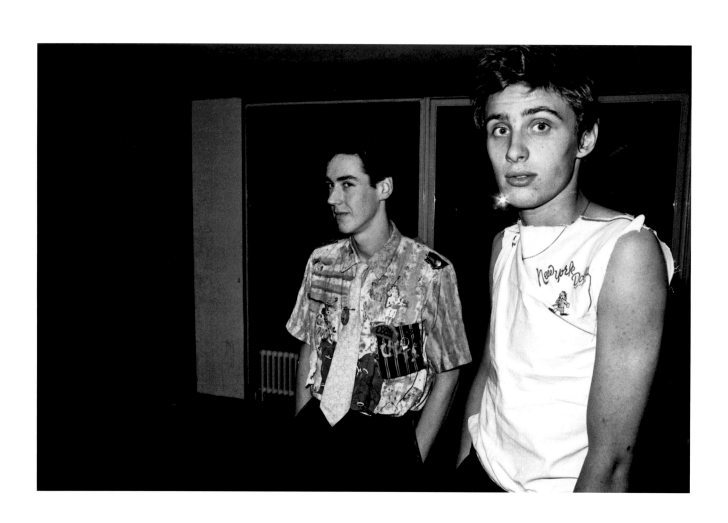

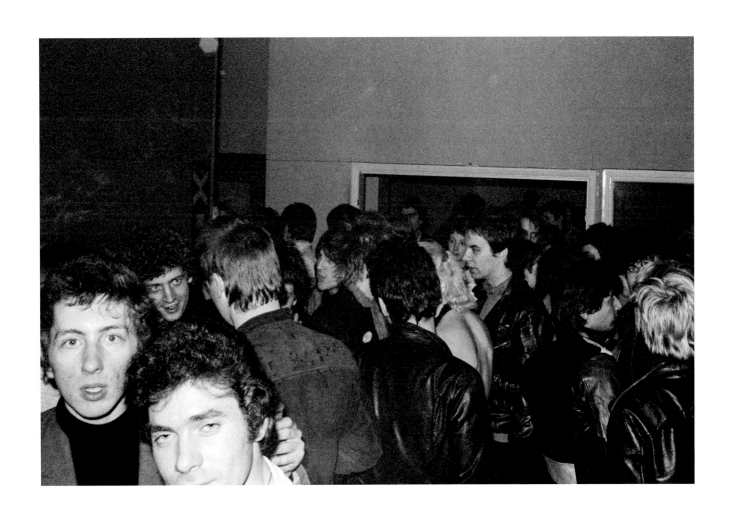

104–5. Generation X under the Westway, May, 1977. Billy Idol is experimenting with hair colour and this month has settled on dark magenta.

106. My guitar hero. Steve Jones, Notre Dame de France, 15 November, 1976.

107. Riveting, intimidating, and funny. John Rotten at Notre Dame de France, 15 November, 1976.

108. Nils Stevenson (Siouxsie and the Banshees manager), Walter Lure and Johnny Thunders (The Heartbreakers), Paul Cook (Sex Pistols), Dingwalls, December, 1976.

109. Subway Sect, the Roxy, December, 1976.

110. *Sounds* writer Vivienne Goldman, Generation X manager Stewart Joseph, the author Jonh Ingham, December, 1976.

111. Vivienne Goldman, *Melody Maker* writer Caroline Coon, December, 1976.

112. Clash fans, "A Night of Treason," Royal College of Art, 5 November, 1976.

113. Another night at the Roxy, January, 1977.

115. Andy Czezowski, owner-operator of the Roxy.

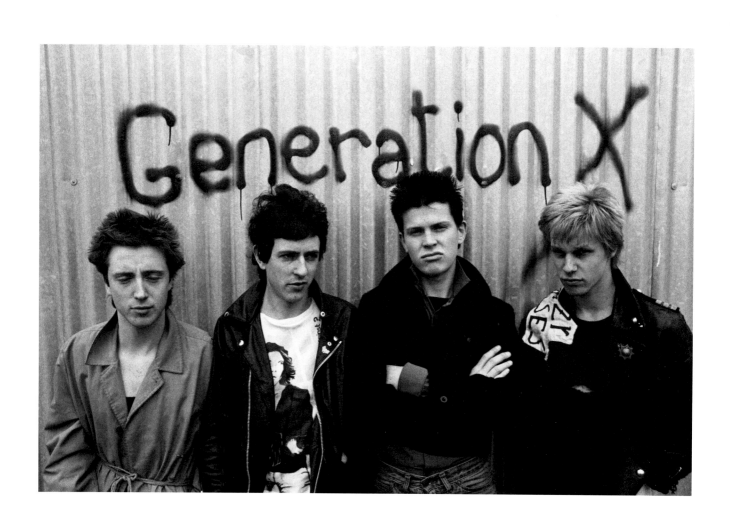

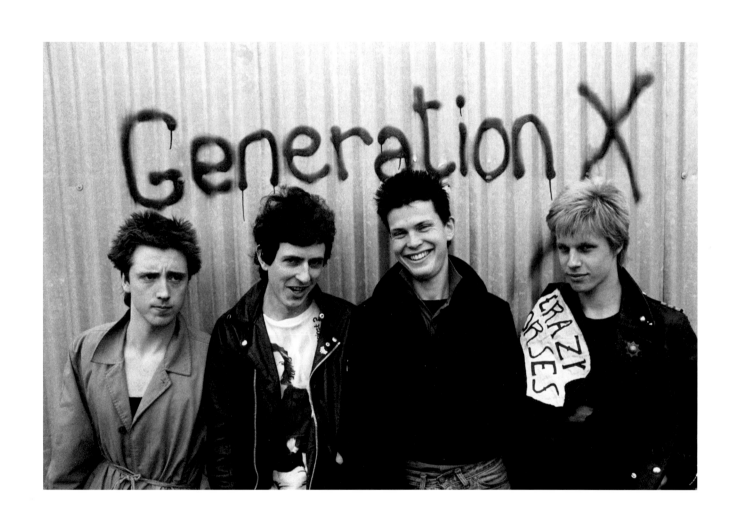

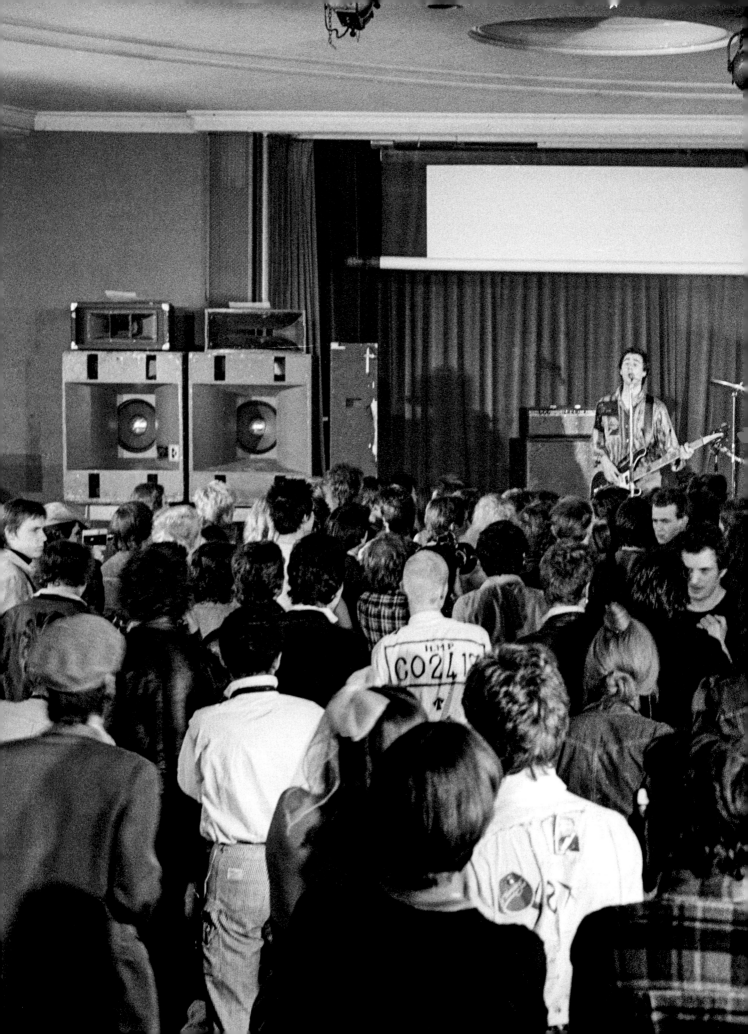

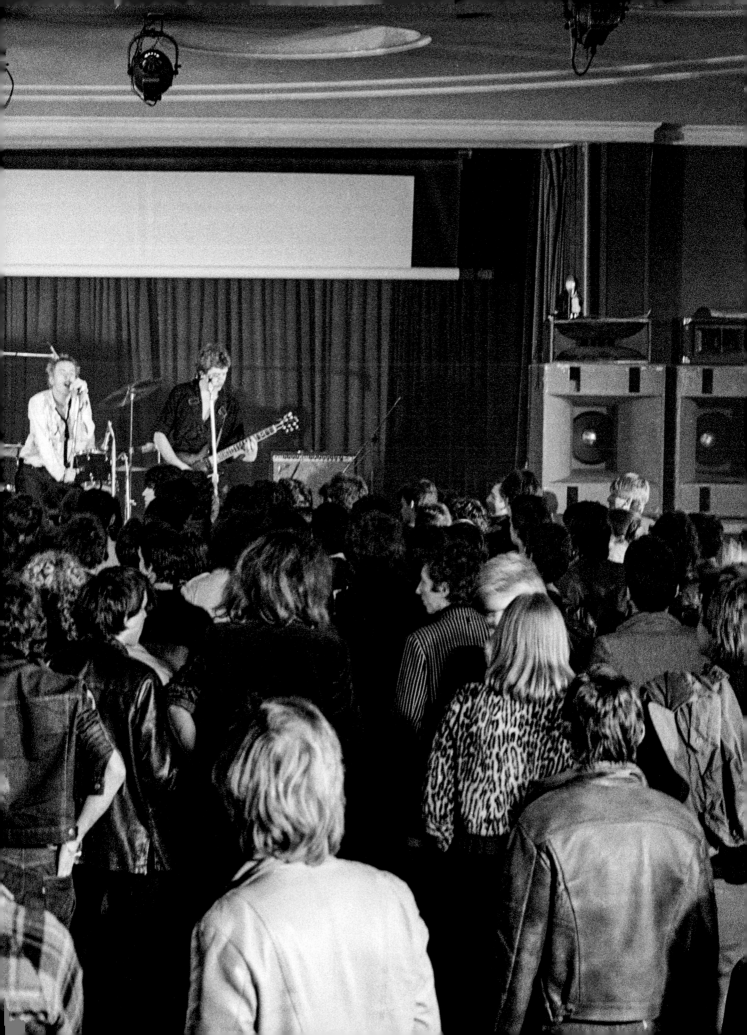

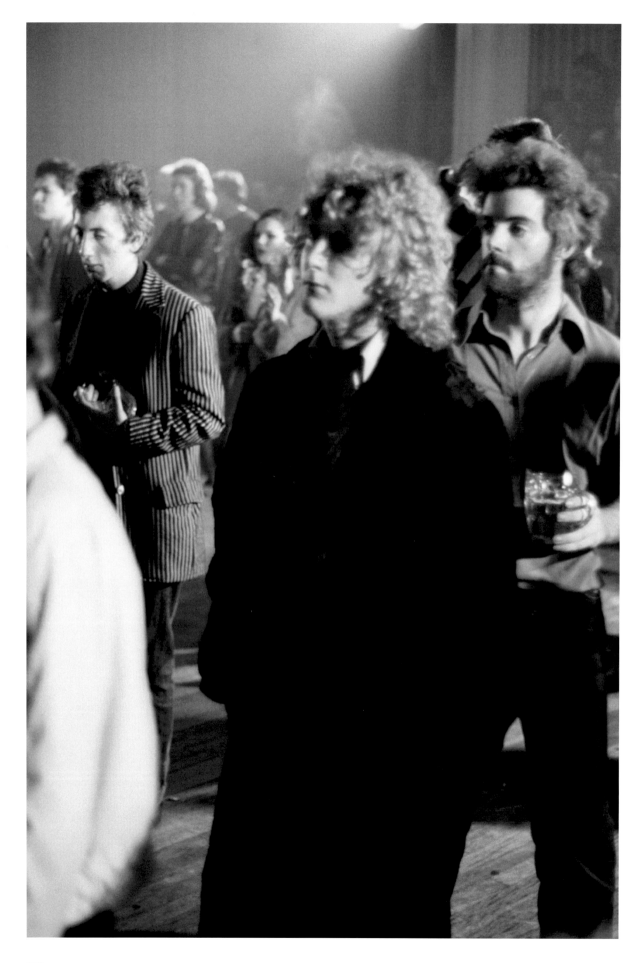

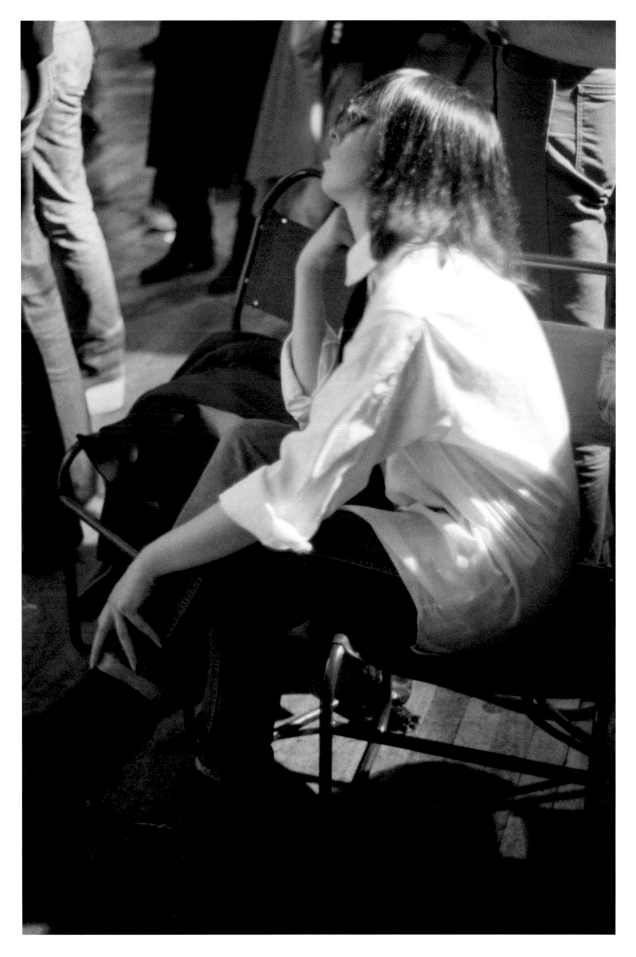

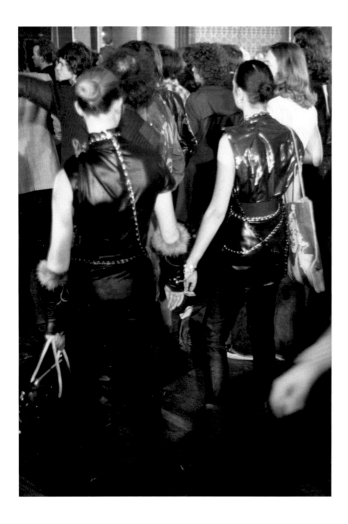
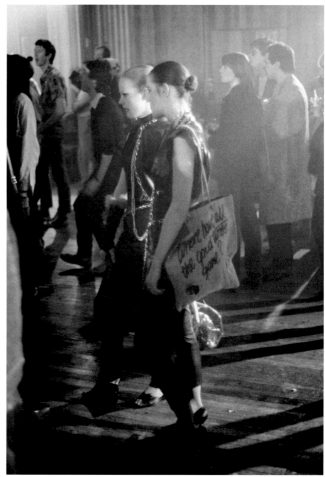

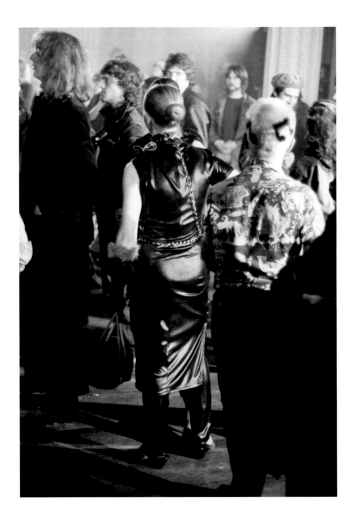
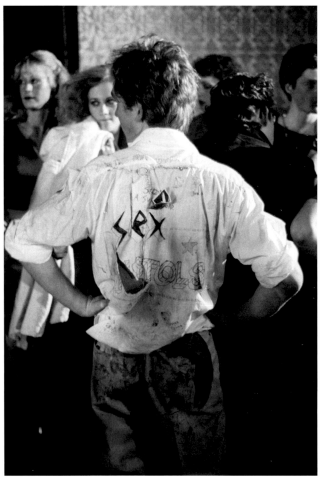

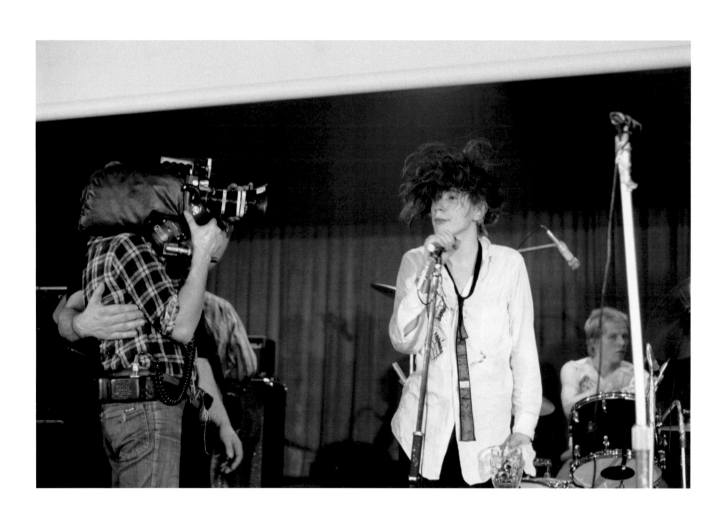

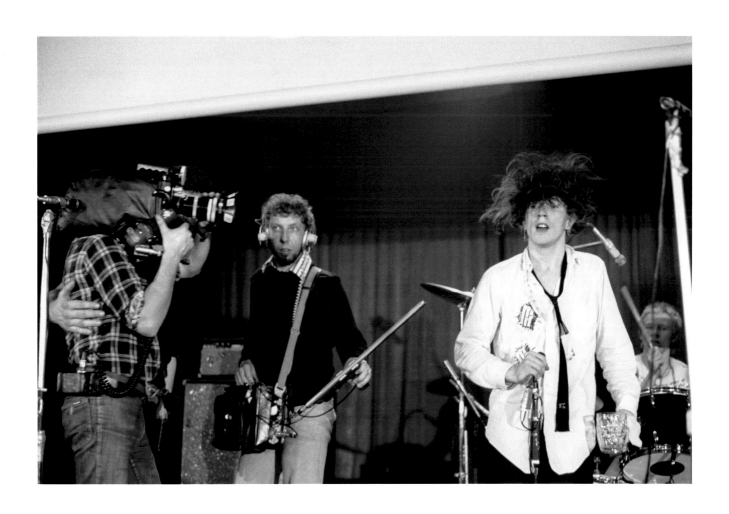

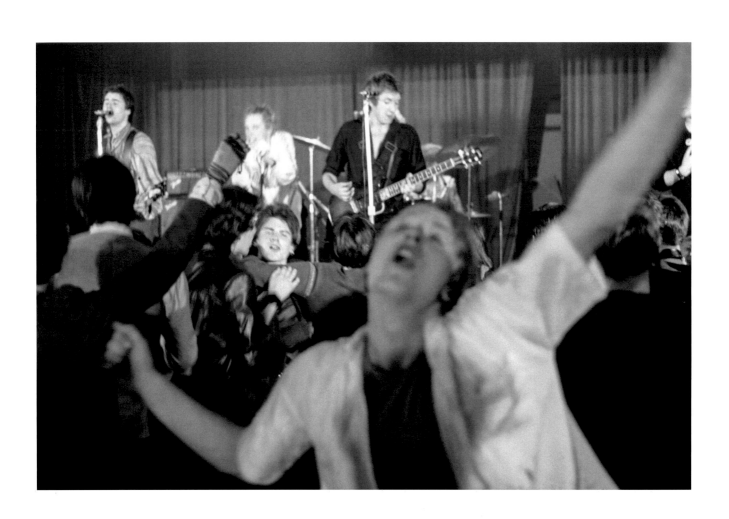

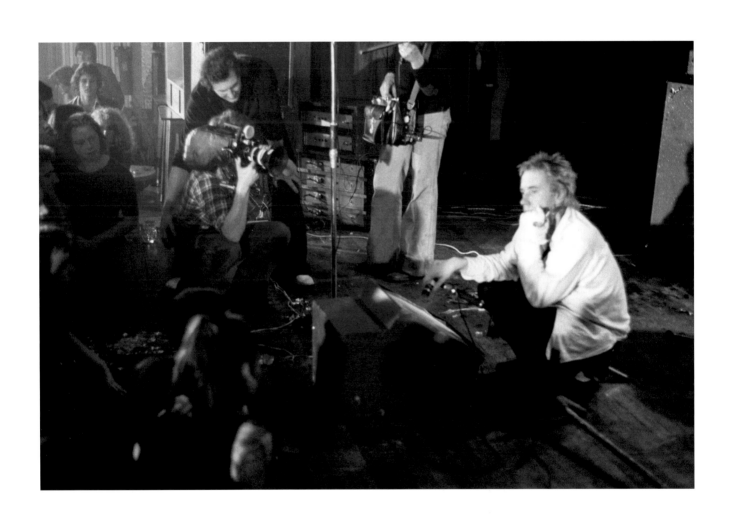

127

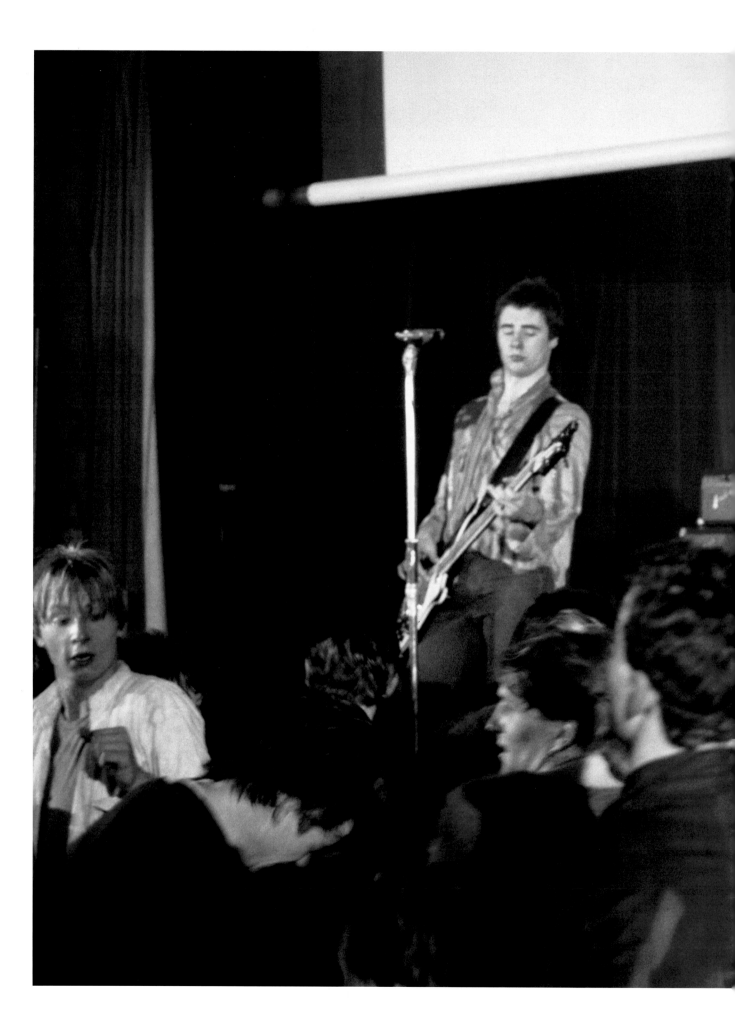

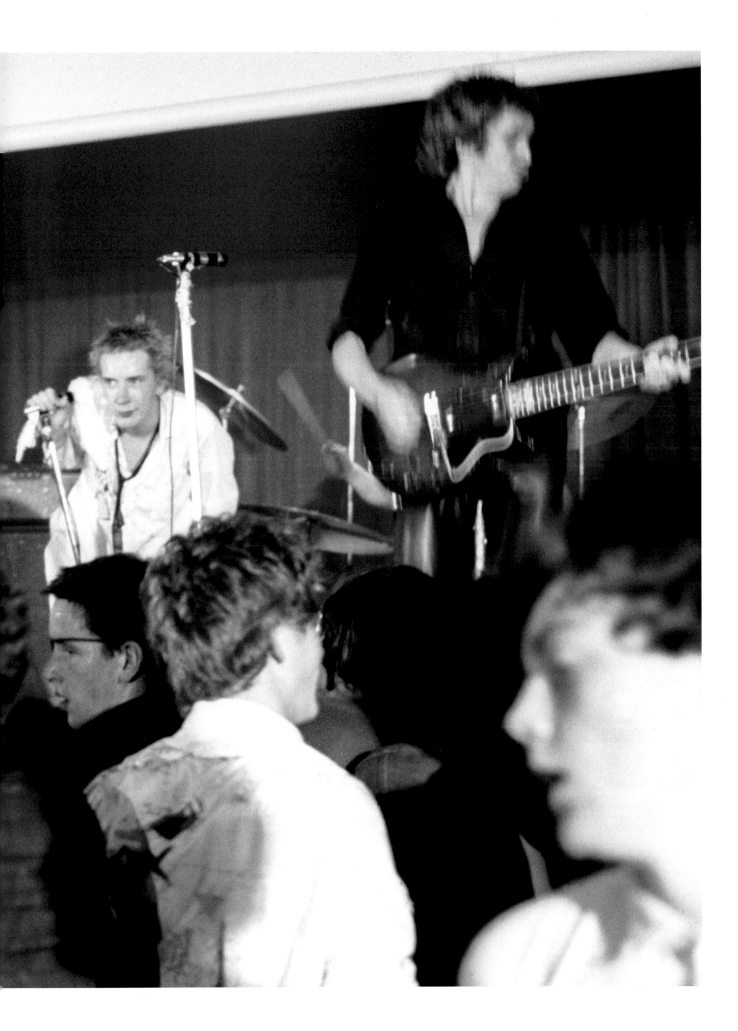

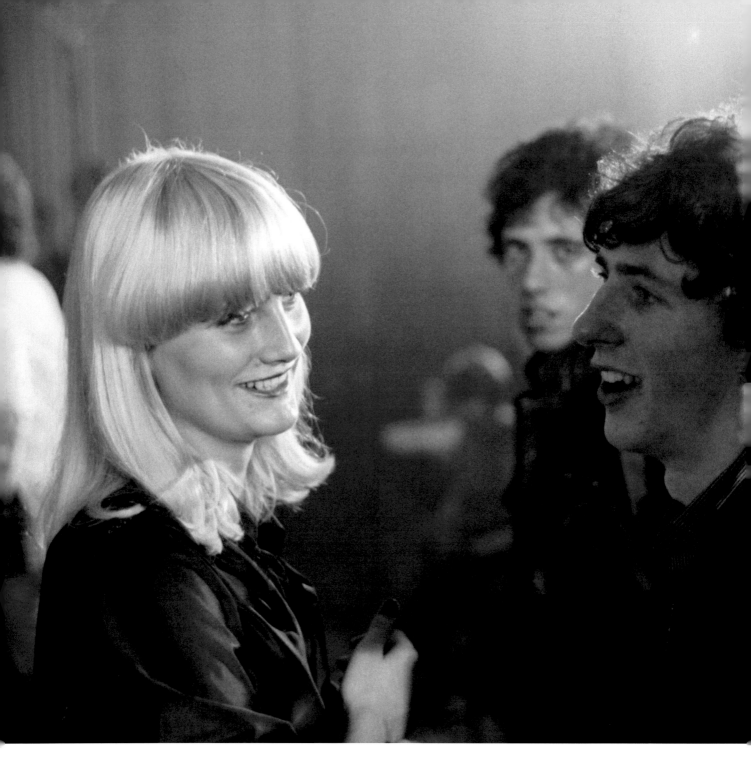

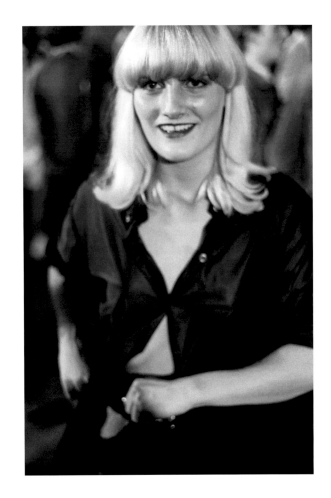

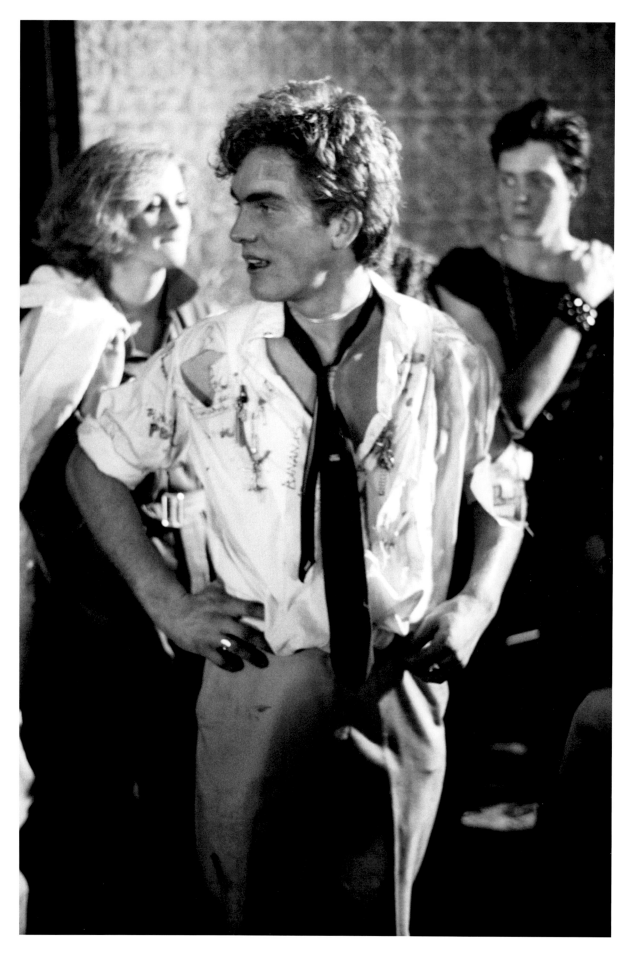

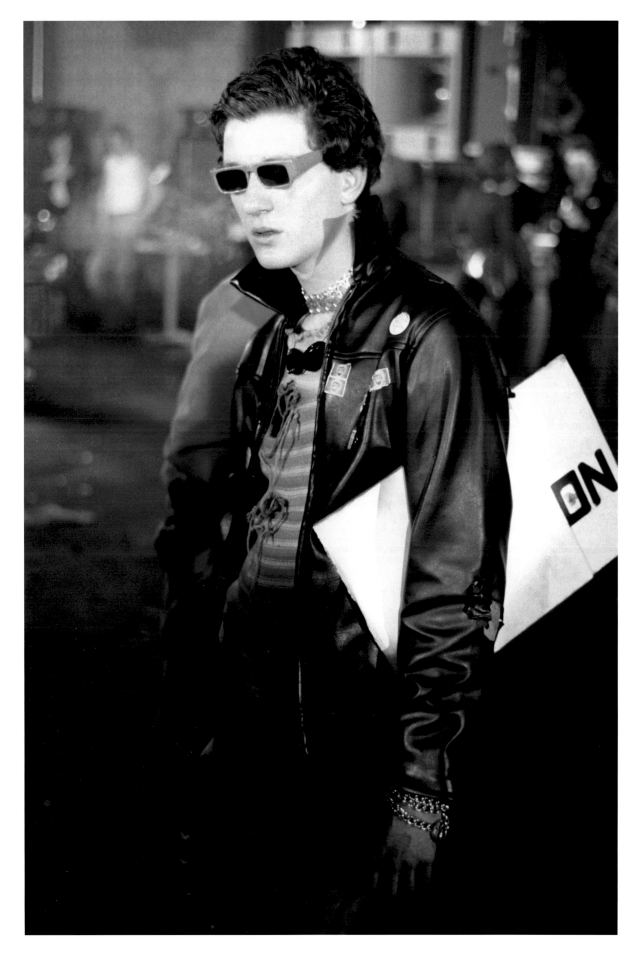

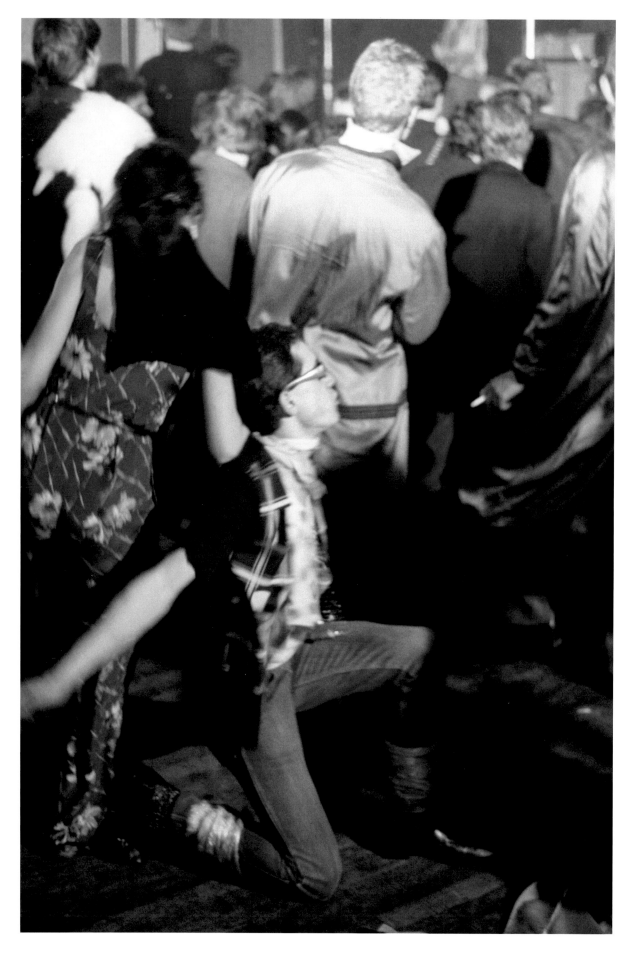

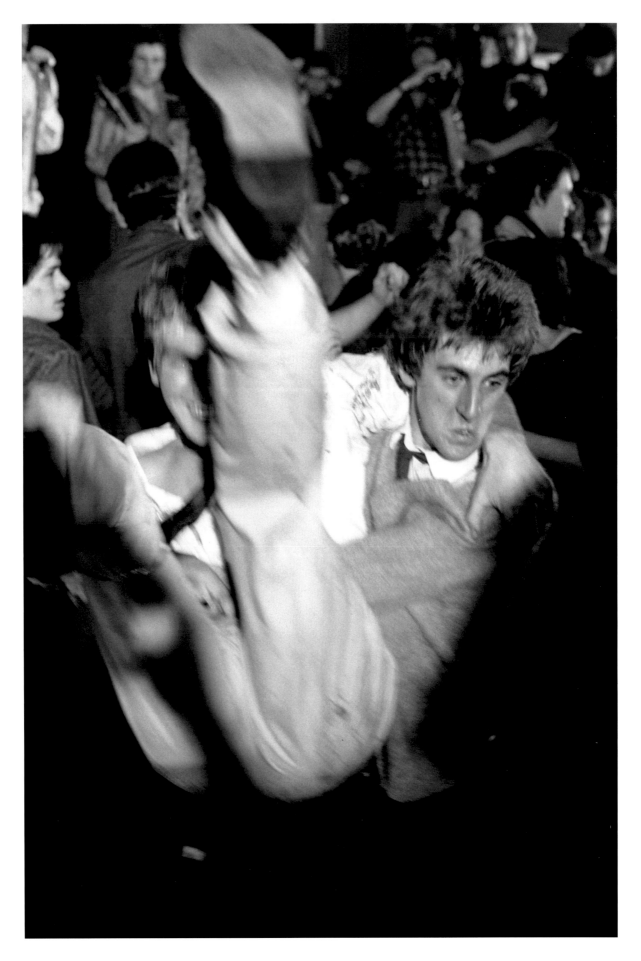

116–7. Crazy horses. Generation X under the Westway. May, 1977.

118–9. Notre Dame de France, 15 November, 1976. The rules were not yet set for what constituted Punk fashion. So everything from plastic bin liners to fake leopard print fur was acceptable. If you had the attitude, you had the look.

120–1. Audience at the Sex Pistols, Notre Dame de France, 15 November, 1976.

122–3. There were a lot of new faces at the Notre Dame show. The curious were obvious. More unusual were people like this couple, clothed in Lycra and bin liners, shopping bags on their shoulders and handcuffed together.

124–5. While the TV cameras were setting up, John found ways to keep himself amused. Notre Dame de France, 15 November, 1976.

130. Mick Jones, Tony James and Billy Idol with a friend. Notre Dame de France, 15 November, 1976.

132. Fan.

133. Ray Burns aka Captain Sensible (The Damned). Notre Dame de France, 15 November, 1976.

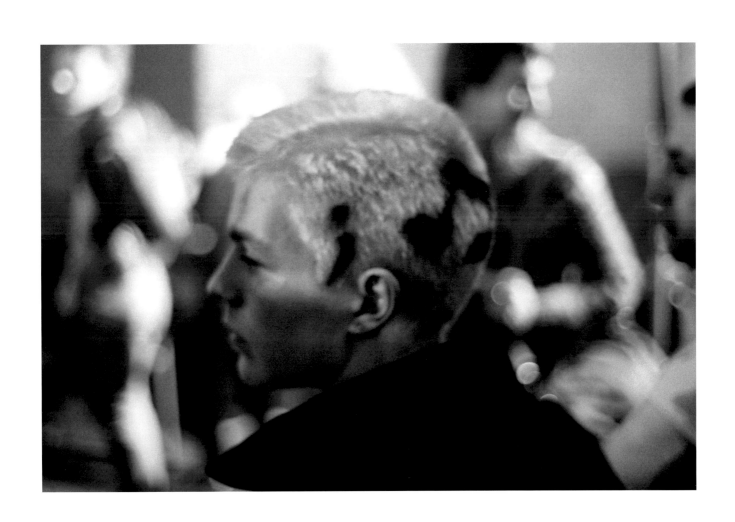

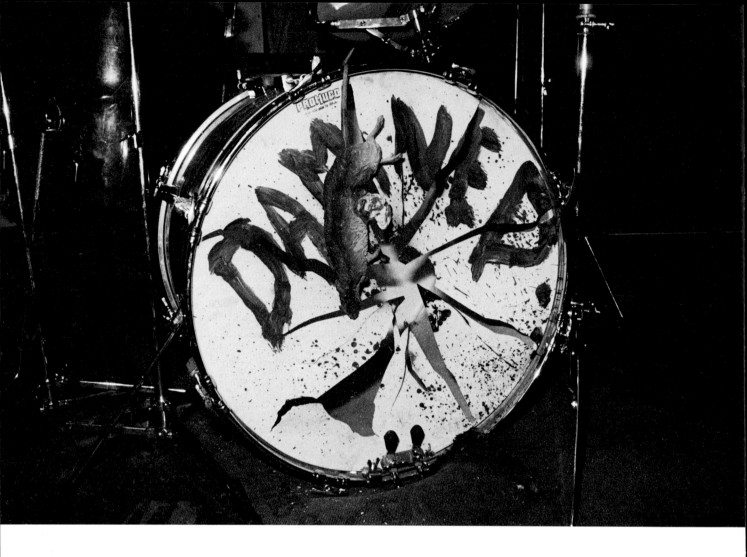

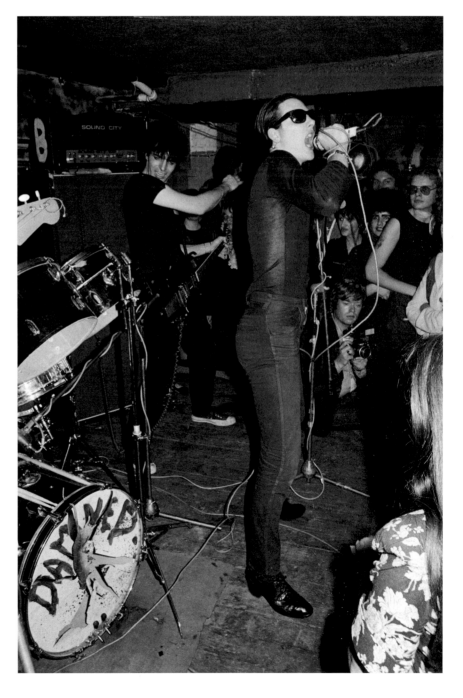

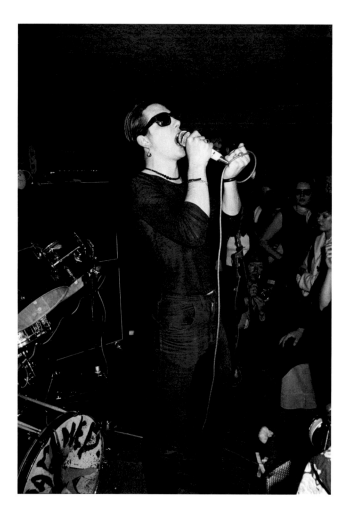
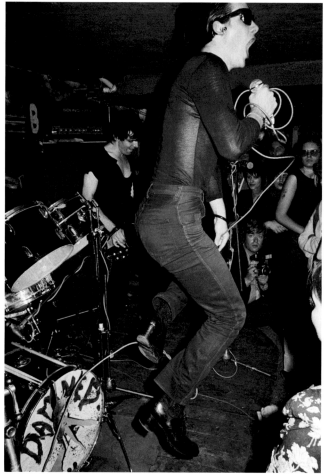

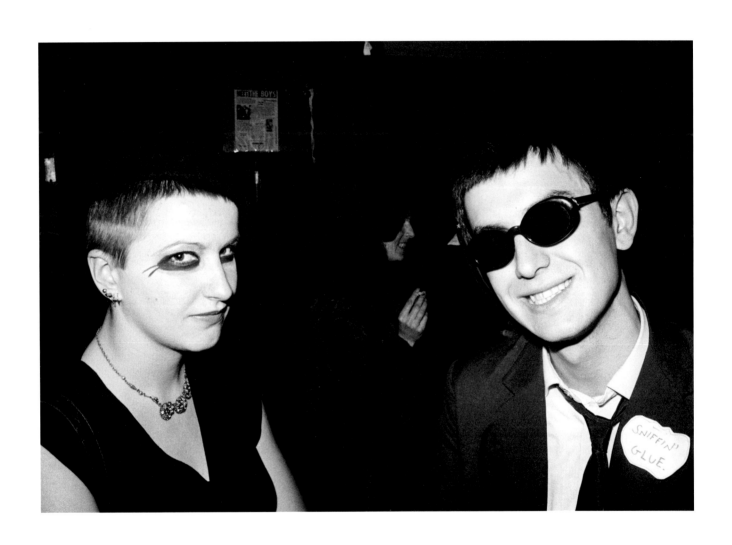

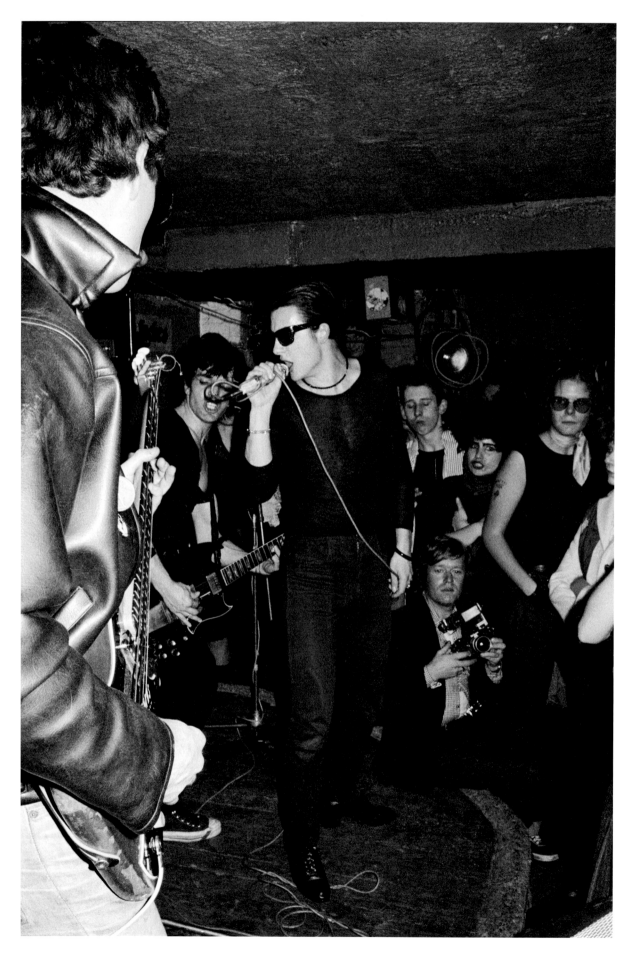

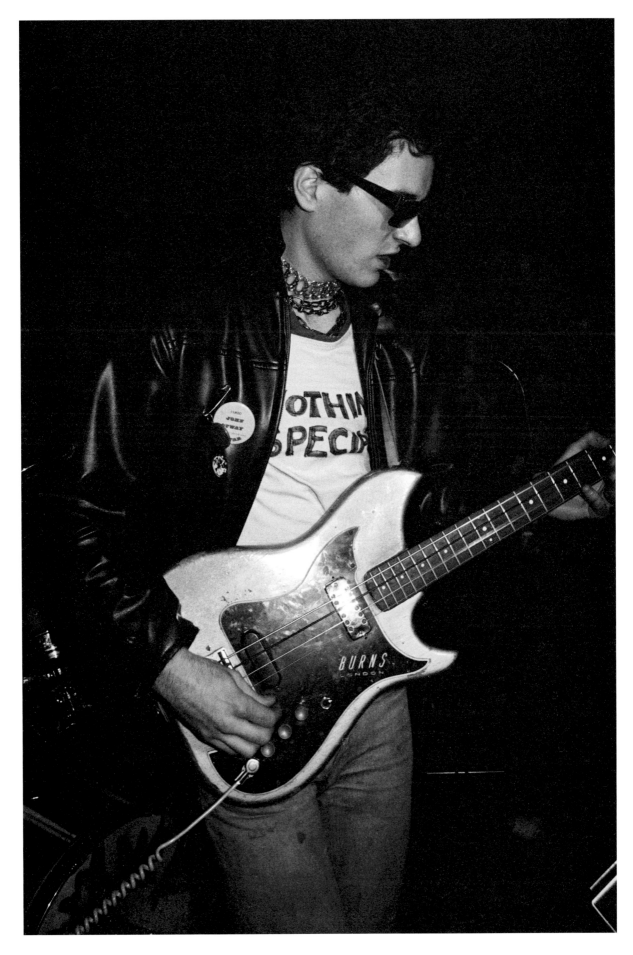

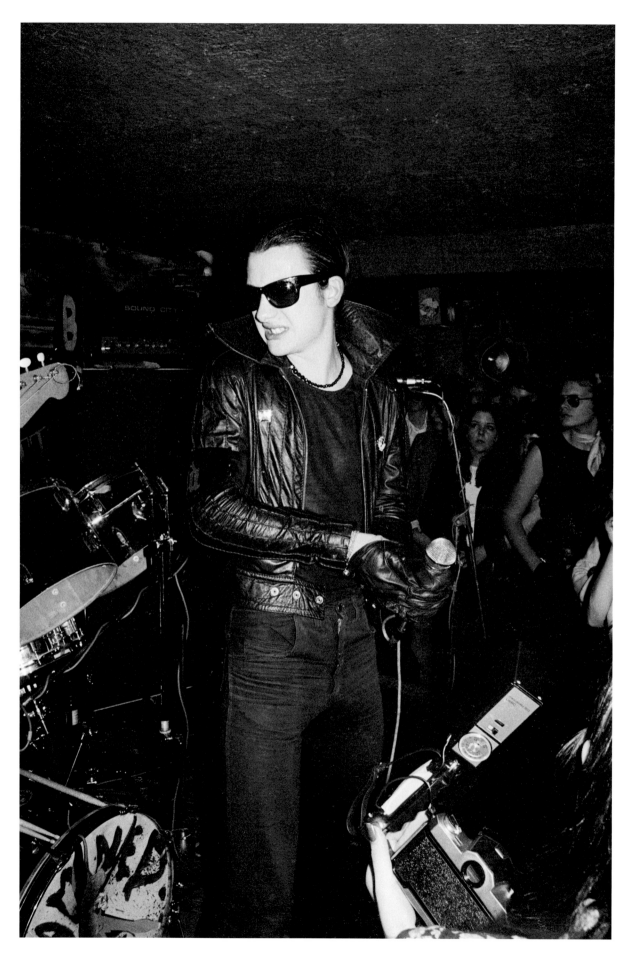

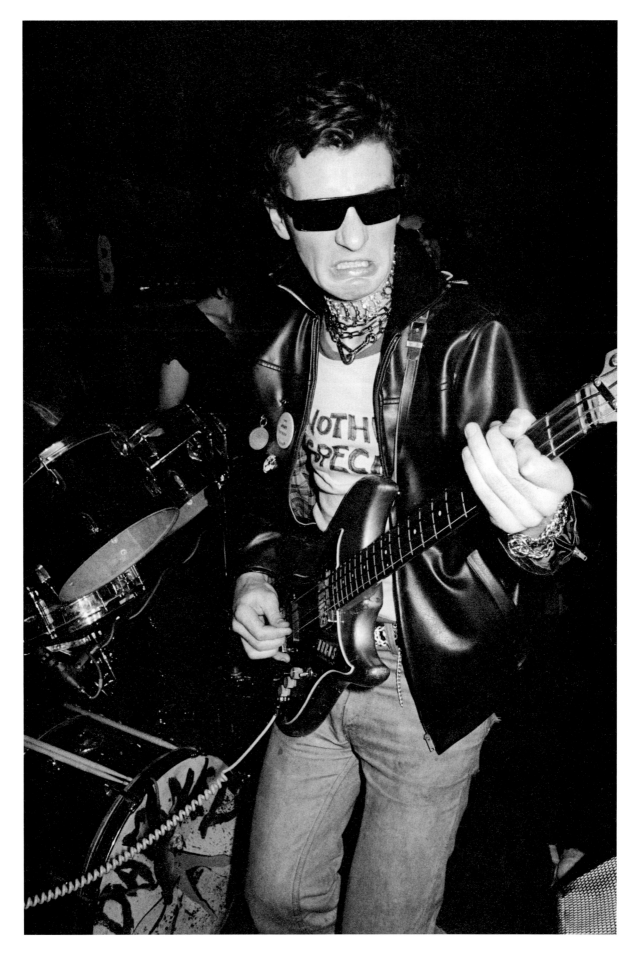

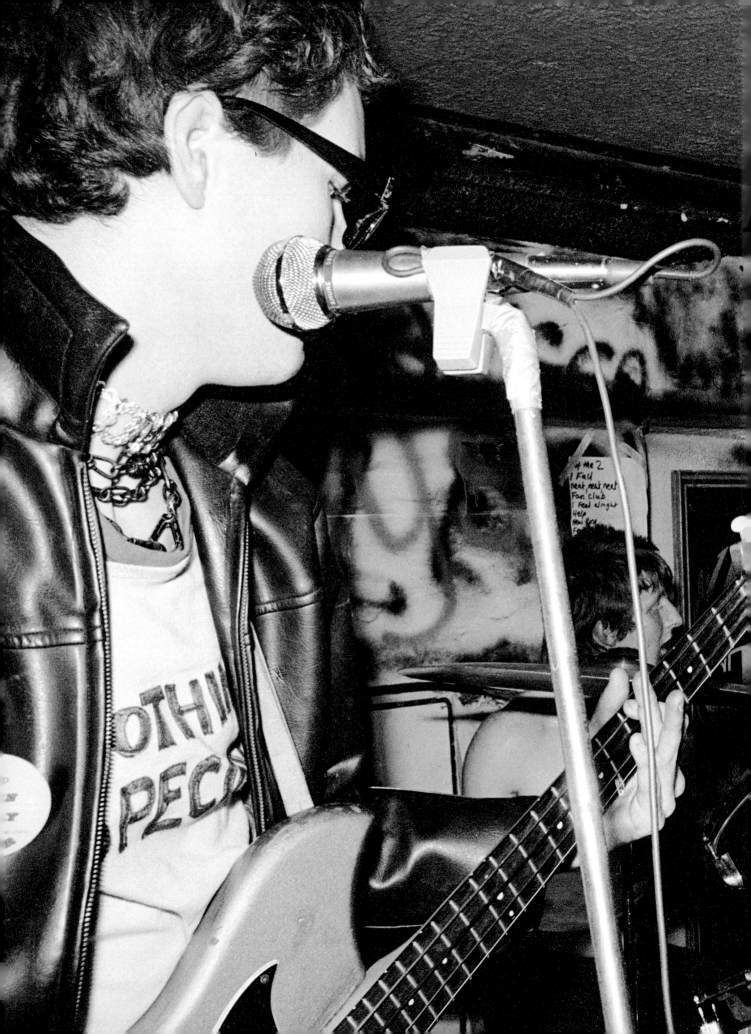

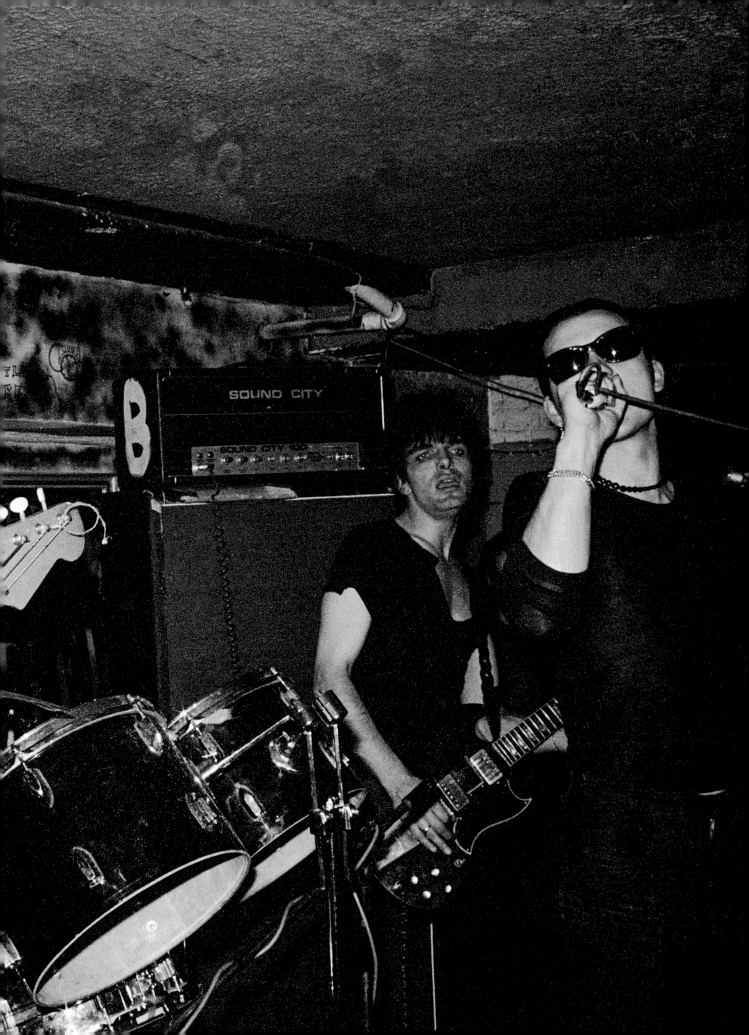

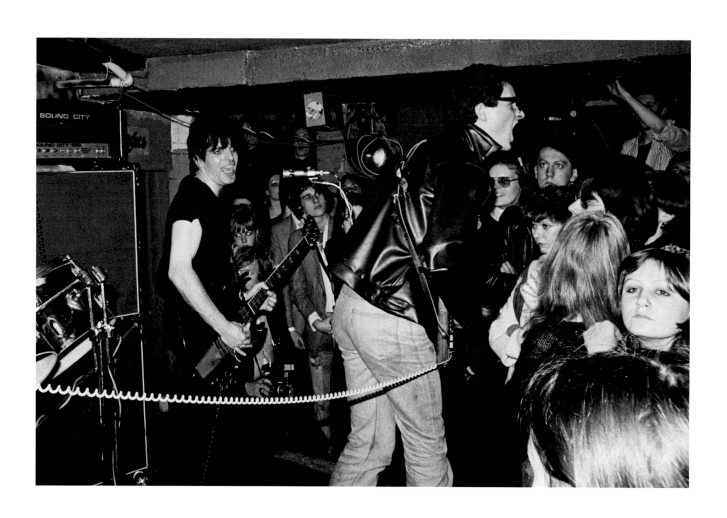

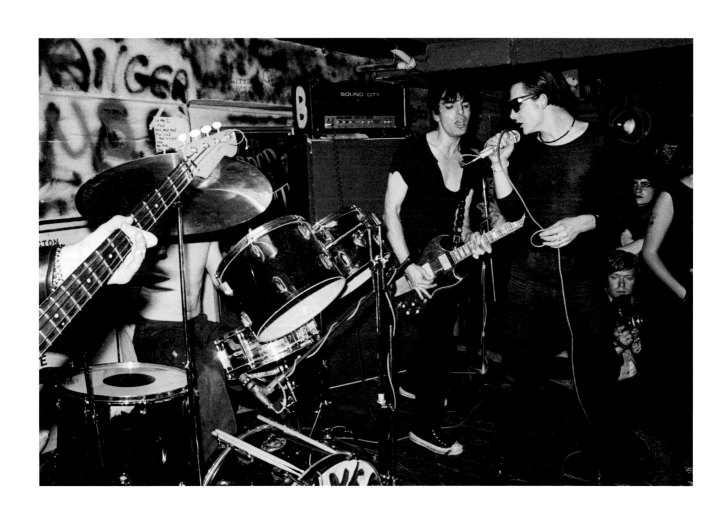

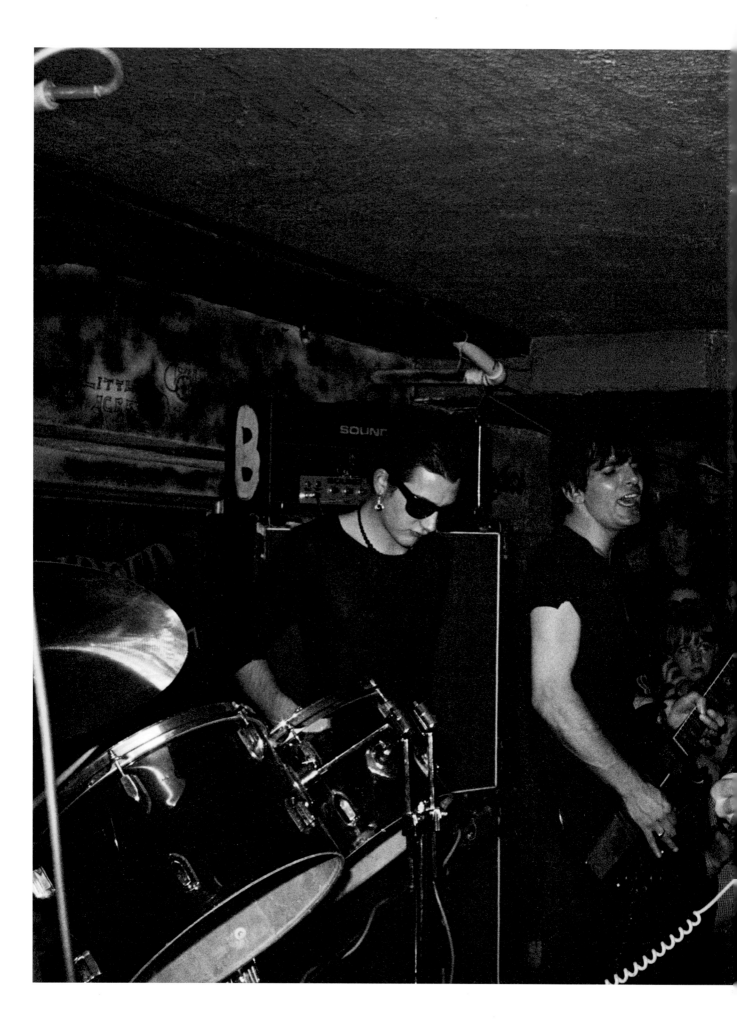

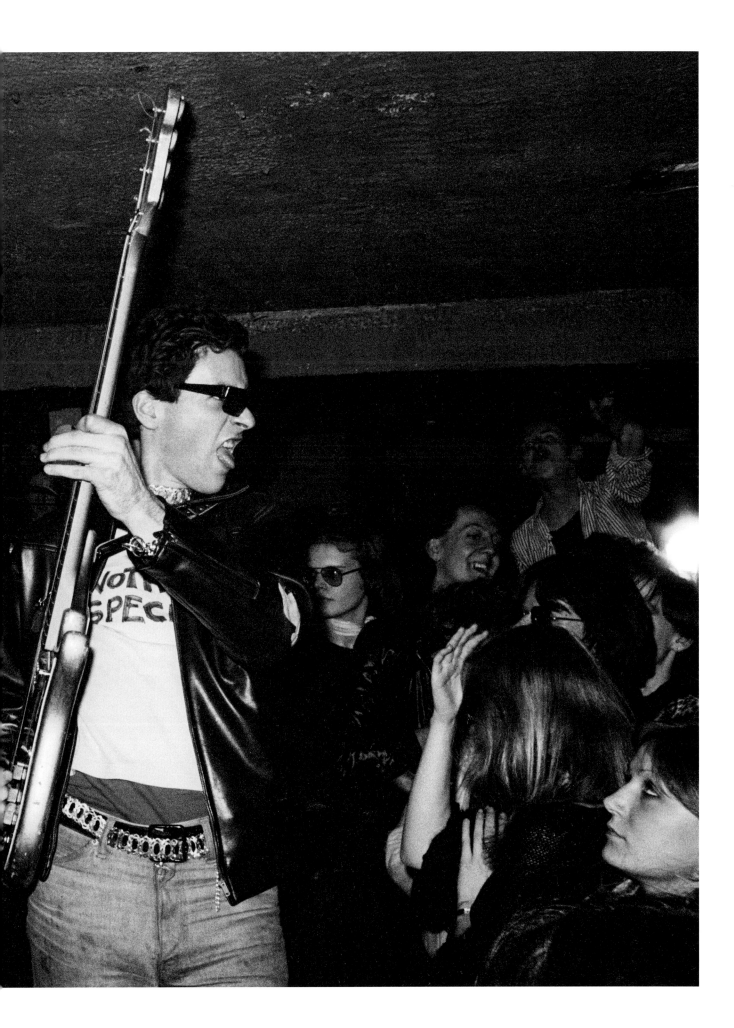

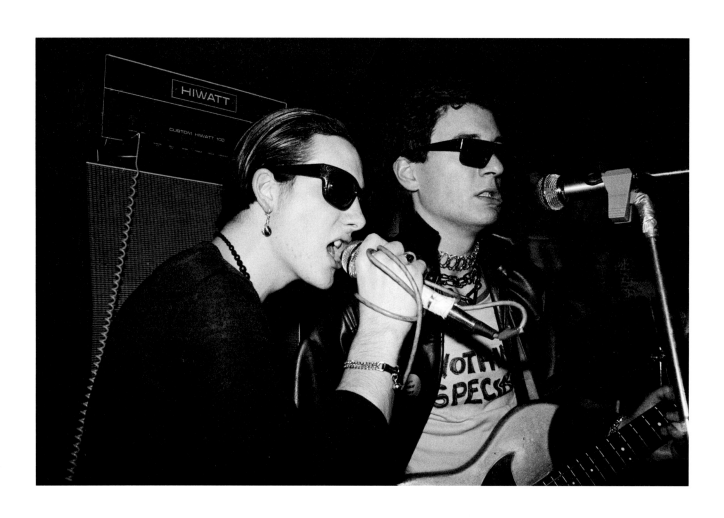

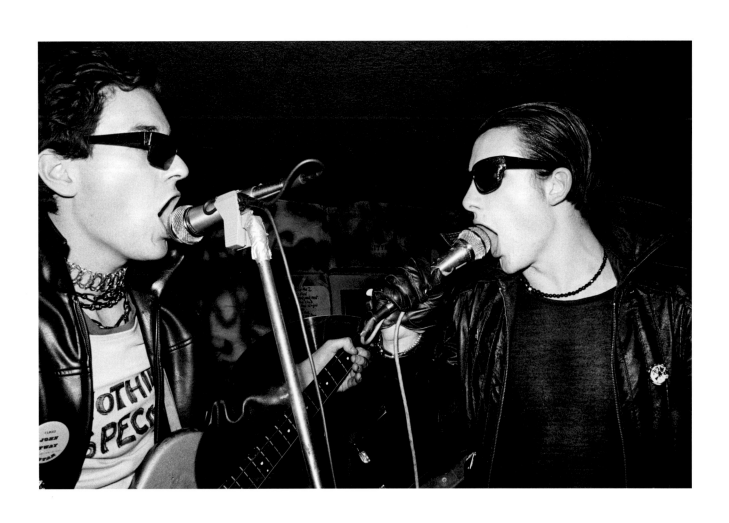

138. The Damned opened 1977 at the Hope & Anchor, a pub in Islington with a history of live bands. Comfortably holding about 100 people, there were double that number crammed in. Sweat was running down the walls. 2 January, 1977.

139. Dave Vanian, Brian James, the Damned, Hope & Anchor, 2 January, 1977.

142. Band and fans. Immediately behind Dave is Shane MacGowan, soon to start the Nipple Erectors and then the Pogues.

143. Captain Sensible, Hope & Anchor, 2 January, 1977.

146–7. Captain Sensible, Rat Scabies, Brian James, Dave Vanian, Hope & Anchor, 2 January, 1977.

155. By November, 1976, Punk was big enough that hundreds would turn up to see the bands in central London. But go 10 miles east to Ilford and 20 people showed up to see the Clash. And 15 of them knew the band. While those 15 watch, two Punks who travelled from Wales to see the band take to the dance floor. Lacey Lady, Ilford, 11 November, 1976.

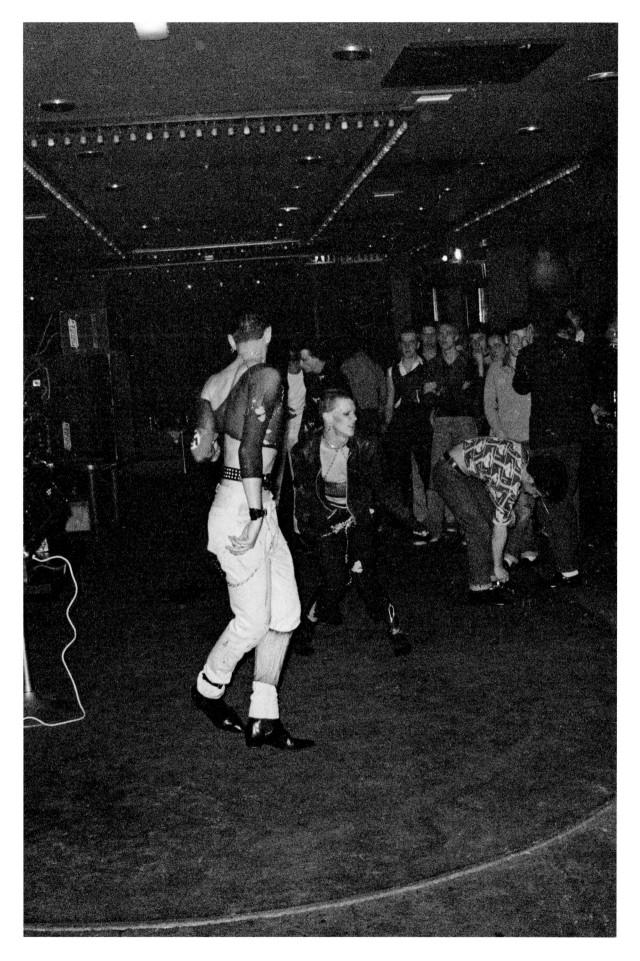